Splendour of the Canadian Rockies

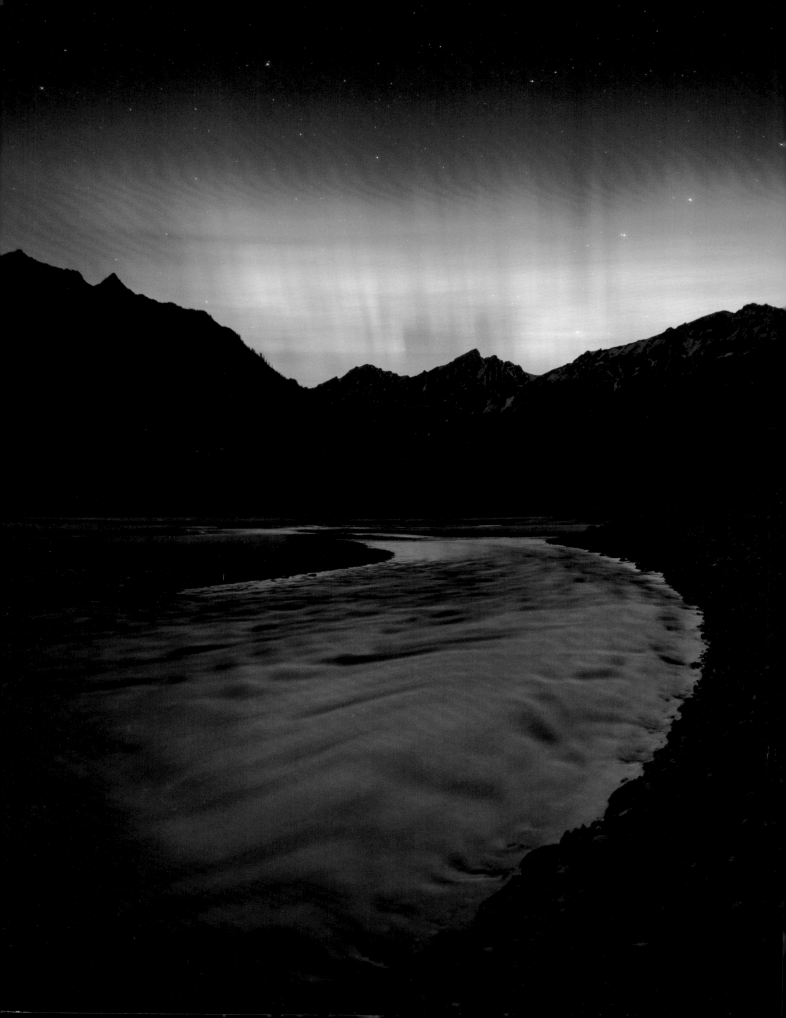

SPLENDOUR
of the
CANADIAN ROCKIES

RMB

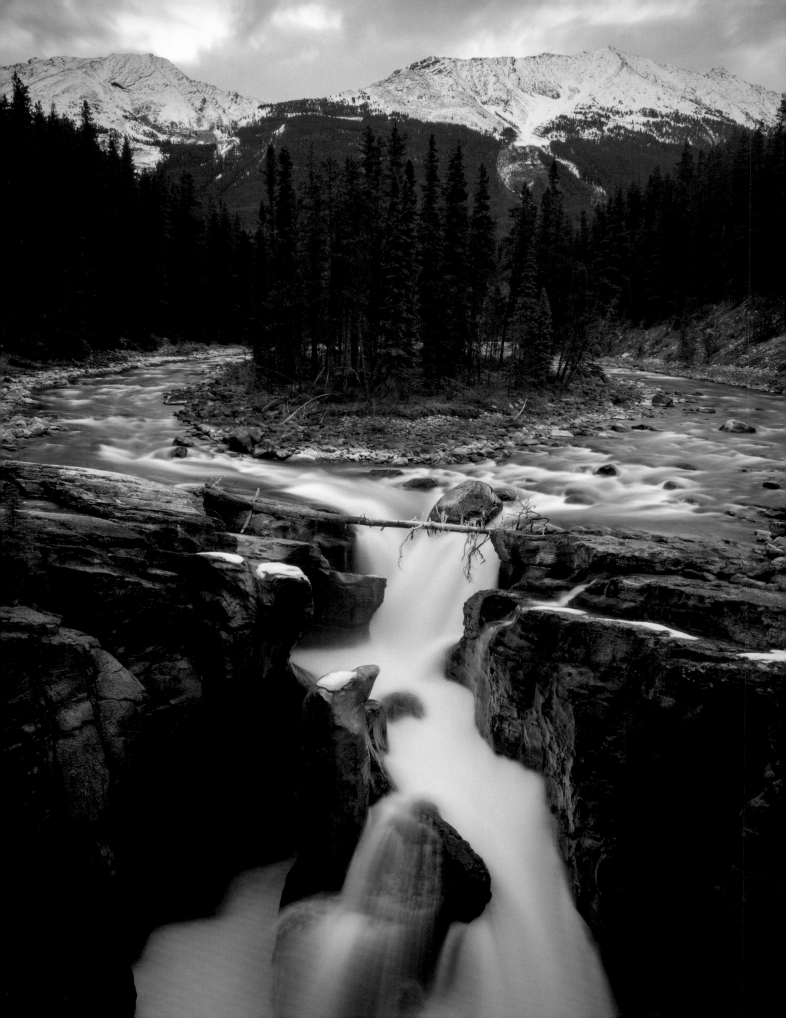

CONTENTS

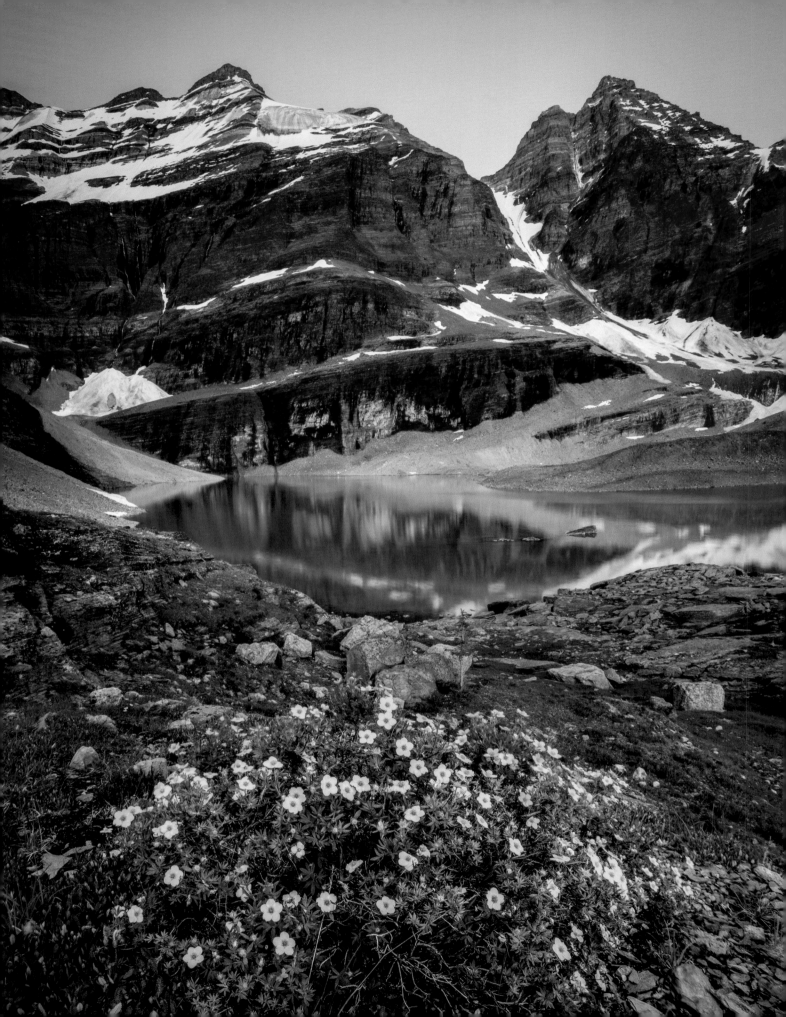

With glacier-clad peaks rising high into the sky, rugged moraines intermixed with turquoise lakes, and ice-cold rivers carving their way through lush, flower-filled valleys, the beauty of the Canadian Rockies is simply overwhelming. While they are not the highest peaks in the world, these spectacular mountains possess an incomparable allure and grandeur that sets them apart on the global stage. It is little wonder that people have long been attracted to this unique corner of Canada, whether for exploration, a brief visit or to set down their roots.

Equal to the beauty is the impressive history of the region. On a geological scale, the Canadian Rockies began to form about 140 million years ago, and more recent periods of glaciation carved the U-shaped valleys that define the landscape today. Though any remaining ice is disappearing rapidly, it is still possible to see the relics of ice ages in the form of icefields and glaciers that flow towards the valleys like frozen rivers.

A shrubby cinquefoil grows in this subalpine region of Lake Oesa, Yoho National Park.

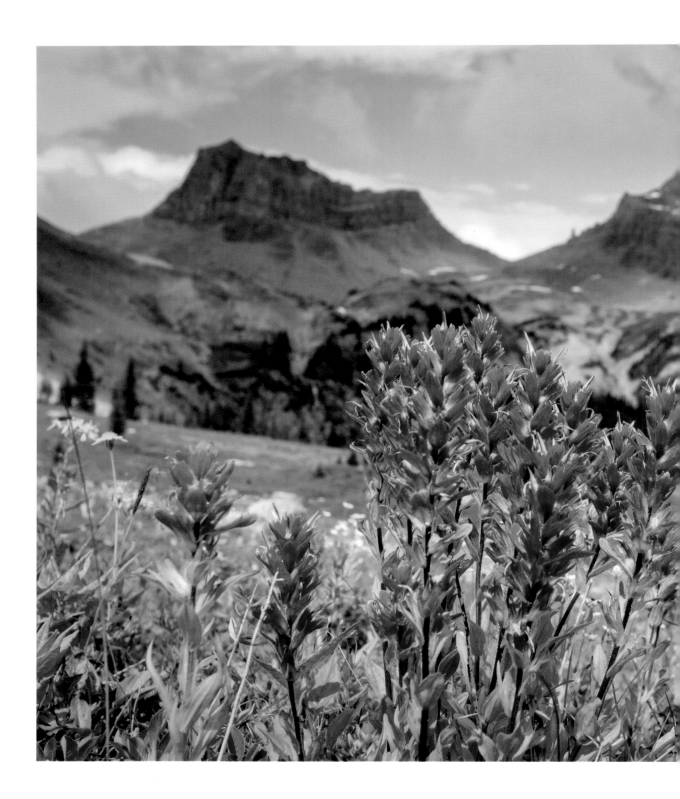

While the region is perhaps better known for its stories of exploration, surveying and mountaineering, archaeological digs have uncovered stone spear points, tools and a human history that dates back as far as 11,000 years. Over the centuries, various First Nations people have called the land home. The Stoney Nakoda called that home the Shining Mountains, likely after the glimmering snow on the peaks.

The modern era of human exploration and development in the Canadian Rockies is recent by comparison, mostly occurring in the past two centuries. That history centres around the railway and a burgeoning tourism industry. As the Canadian Pacific Railway (CPR)

One of the most abundant and recognizable wildflowers in the Canadian Rockies, the Indian paintbrush comes in a variety of colours, from blood red to pink or orange and, more rarely, yellow or white.

9

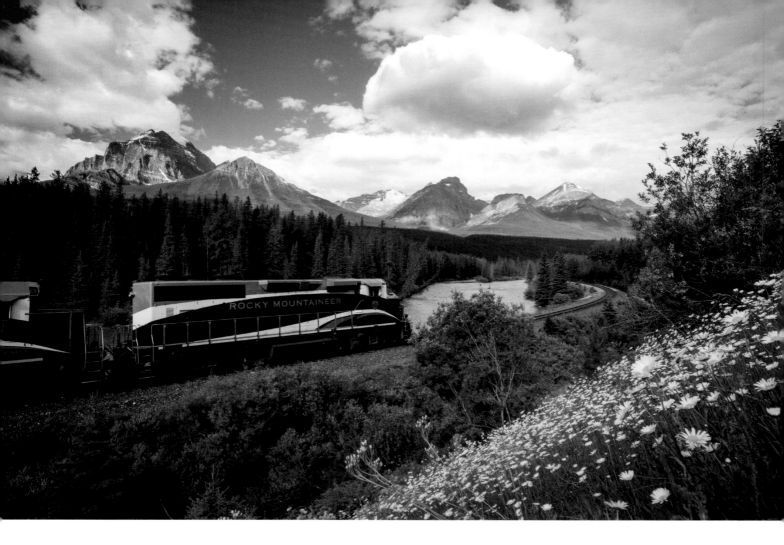

pushed its way West in the 1880s, a timely discovery of hot springs at what is now the Cave and Basin National Historic Site spurred the beginnings of Canada's national parks system, which provided a lucrative way of funding the completion of the railroad. "If we can't export the scenery," CPR president William Cornelius Van Horne so famously

ABOVE *Morant's Curve is a favourite spot for photographers looking to capture an image of a train passing through this scenic location in the Bow Valley. It is named after a photographer who did just that: Nicholas Morant took photos for the* CPR *in the mid-20th century. Many of his images used in the company's promotional materials featured this very spot.*

said, "we'll import the tourists." Since then, tourism has largely defined the region. And while millions of visitors come from around the world each year, the region also possesses a vast wilderness that lies largely untouched.

In 1984, UNESCO included the Canadian Rocky Mountain Parks – Banff, Jasper, Kootenay and Yoho – and a number of provincial parks in its list of World Heritage Sites. It is a tribute worthy of a region with such astounding natural features and biological diversity. Whether you're exploring the reaches of the backcountry or viewing the scenery from the roadside, it's no stretch to say that the awesome beauty of the Canadian Rockies will stay with you long after you've left.

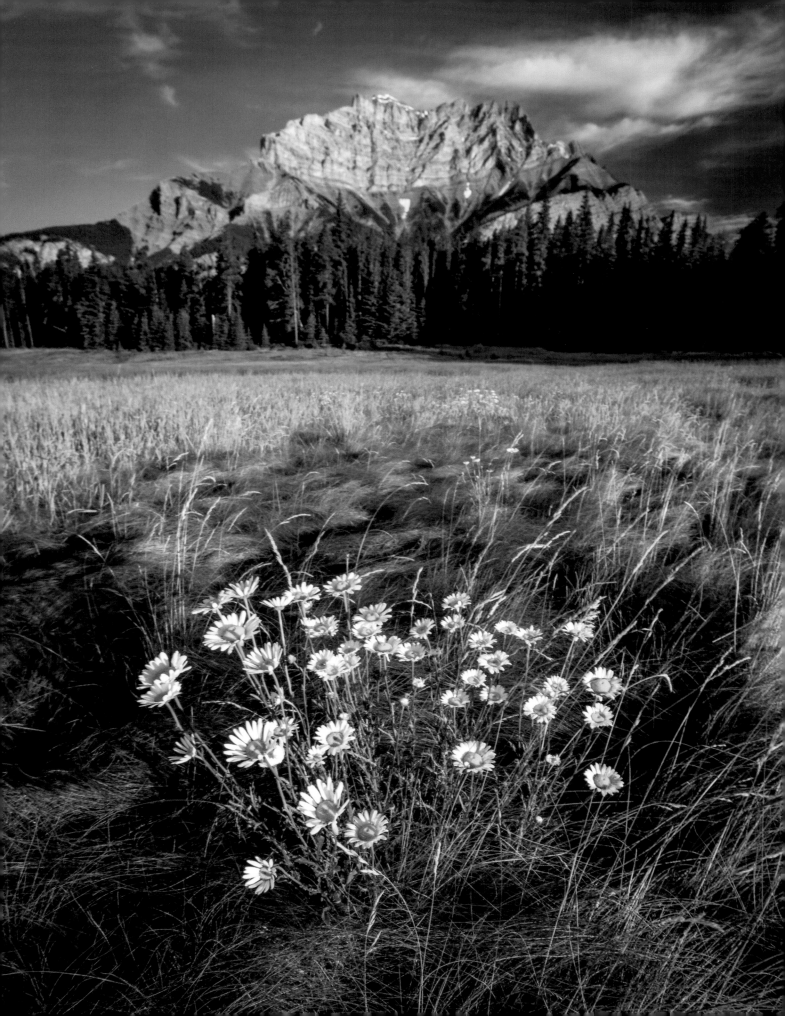

Town of Banff

Celebrated as Canada's highest municipality, and the first one to be incorporated in a national park, Banff is perhaps also one of the nation's most famous small towns. Originally it was just Siding 29, a railway settlement established by the Canadian Pacific Railway in the 1880s. The name of the town can be attributed to a county in Scotland called Banffshire, which was the birthplace of the CPR's first president, George Stephen.

Surrounded entirely by Banff National Park, the scenic town offers a vast array of amenities and acts as a gateway to the mountain parks. Travellers base themselves here for year-round adventure, whether it's sightseeing, skiing at one of three local ski areas, hiking some of the best trails in the world, paddling a pristine lake or snowshoeing in freshly fallen snow.

Perhaps the most iconic peak near the town of Banff, Cascade Mountain was named in 1858 by James Hector as a translation of its Stoney name, Minihapa, or "mountain where the water falls," which references the prominent waterfall on its southeastern face.

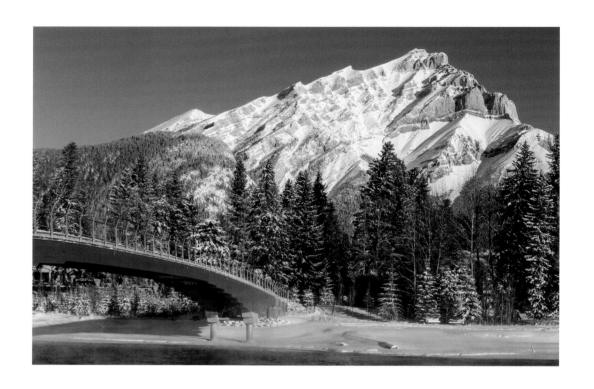

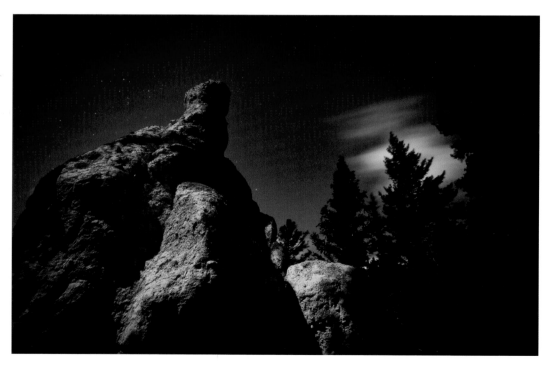

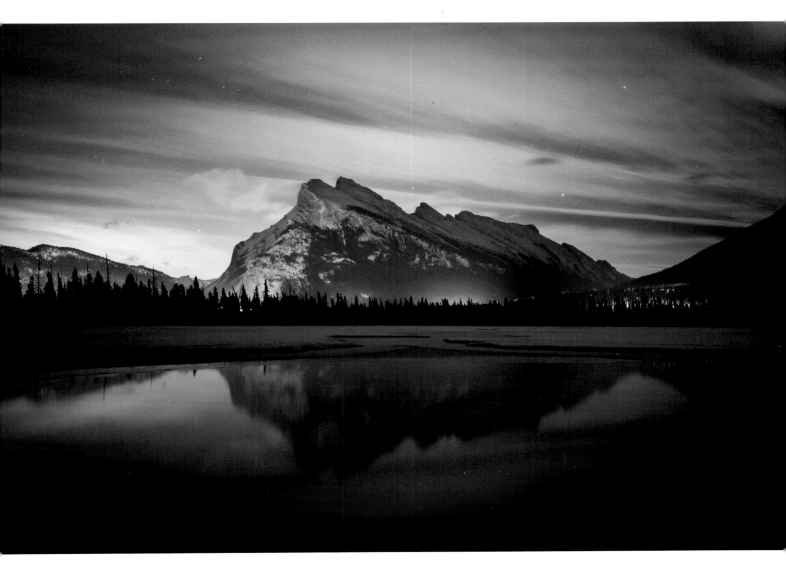

The subtle glow of the town of Banff lights up the lower flanks of Mt. Rundle from one of Banff National Park's most photogenic locations, Vermilion Lakes.

OPPOSITE ABOVE *A layer of fresh snow dusts Cascade Mountain and the banks of the Bow River near Banff's pedestrian bridge.*

OPPOSITE BELOW *Hoodoos are geological formations composed of relatively soft rock covered by harder, less easily eroded rock. Over time, the elements have worn away the surrounding rock, leaving behind these oddly shaped columns.*

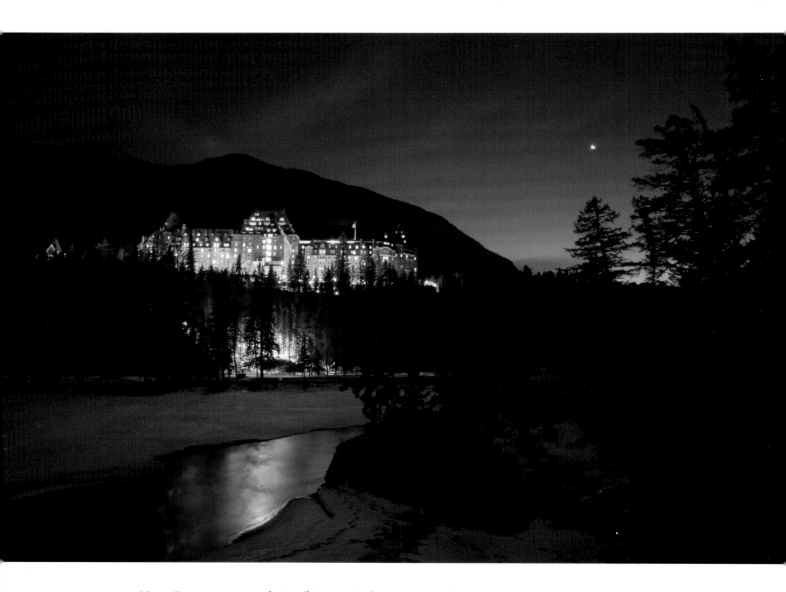

Now a Fairmont property, the Banff Springs Hotel was constructed as part of CPR vice-president William Cornelius Van Horne's grand plan to build luxurious railway hotels throughout the Canadian Rockies. A National Historic Site of Canada, the hotel was the largest in the world when it first opened in 1888, and has since hosted many dignitaries and celebrities.

This aerial photo of Bow Falls offers a unique perspective of the surging waterfall, which cascades towards the confluence of the Bow and Spray rivers.

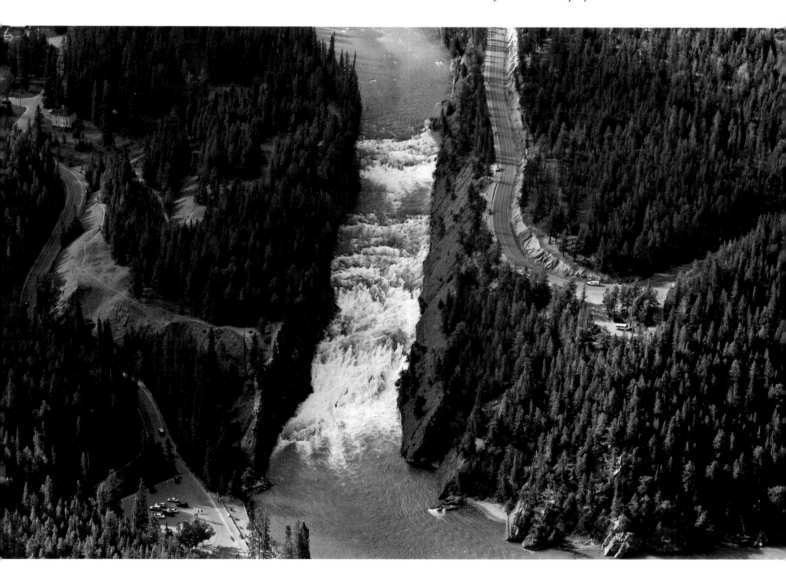

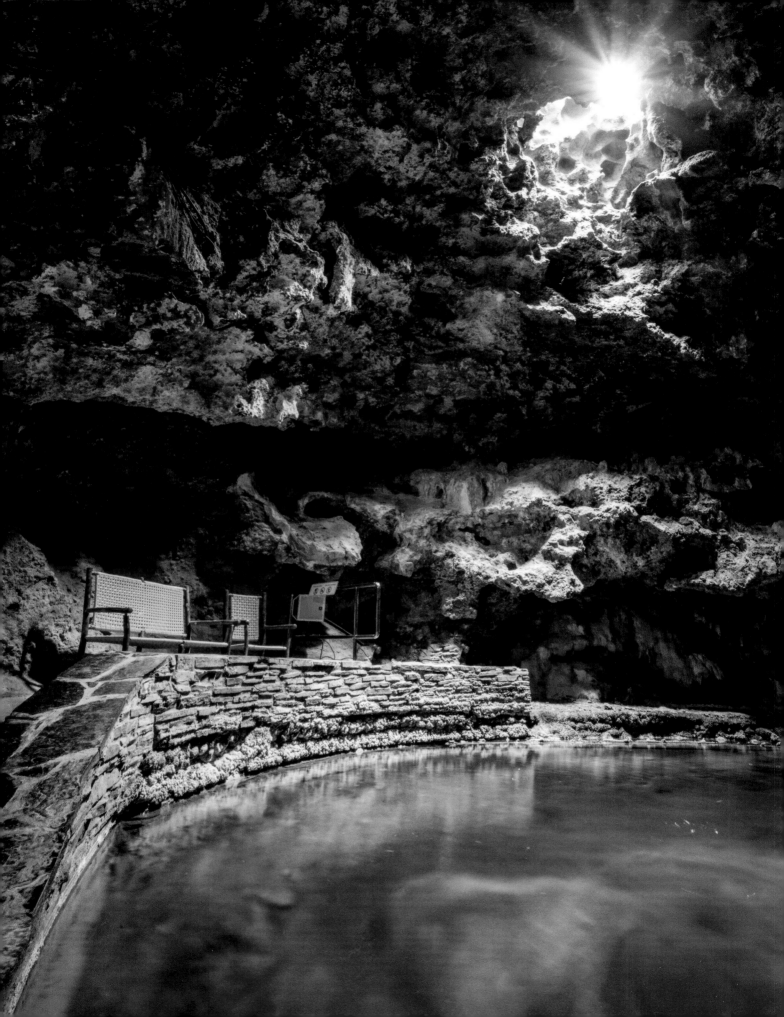

ABOVE *The basin at the Cave and Basin National Historic Site is a warm and inviting pool of sparkling blue water. Today, to help save the endangered Banff Springs snail, visitors are forbidden to dip their toes into these hot springs.*

OPPOSITE *Walk through the tunnel that leads to the cave at the Cave and Basin National Historic Site and you get a waft of the sulphuric smell that emanates from the thermal waters. While First Nations were likely the first to discover and use the waters, the discovery of the cave by three railway workers in 1883 marked an important moment in Canadian history. A heated ownership dispute ensued, fuelled by the potential profitability of the hot springs. Soon the government of Canada stepped in to settle the arguments and created the Hot Springs Reserve in 1885. In 1887, William Pearce drafted the Rocky Mountains Park Act, which expanded the reserve beyond the hot springs to include 665 square kilometres of wilderness. This was Canada's first national park.*

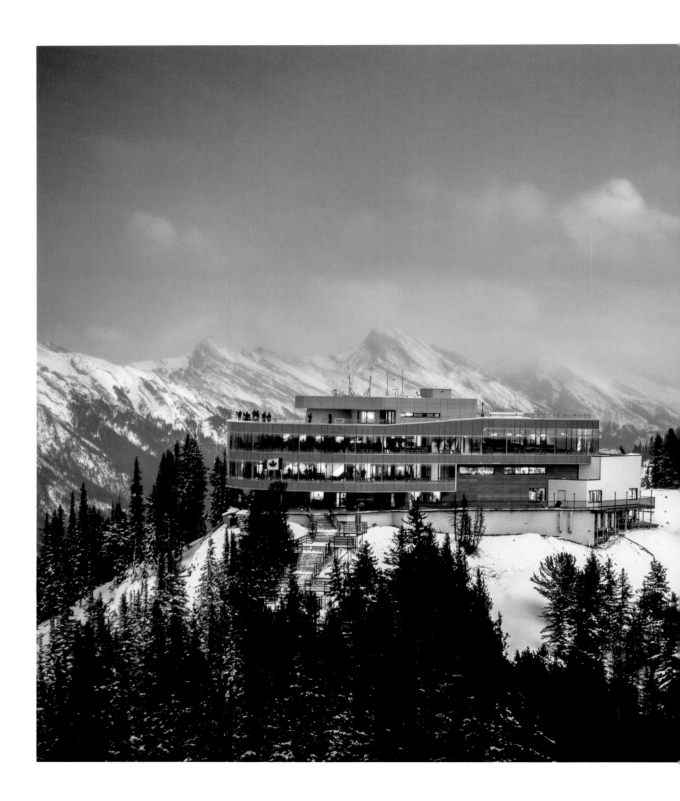

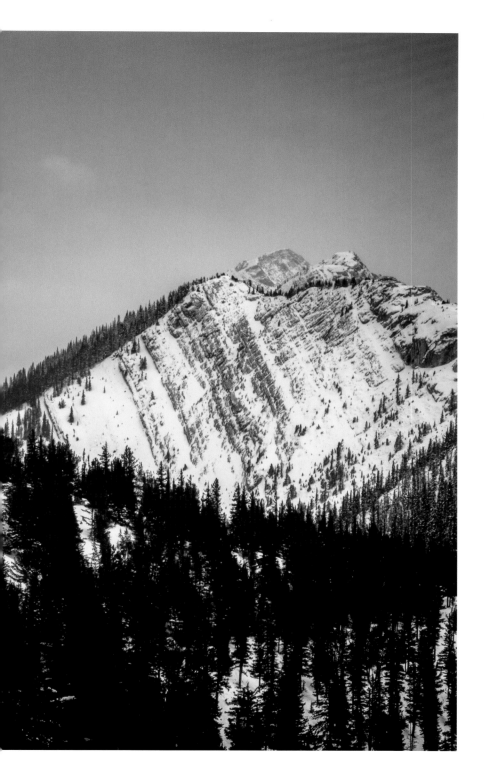

The Sulphur Mountain Gondola climbs 700 metres up the side of its namesake peak to an upper terminal, a state-of-the-art venue featuring interpretive displays, a gift shop and restaurants with the best views in the region.

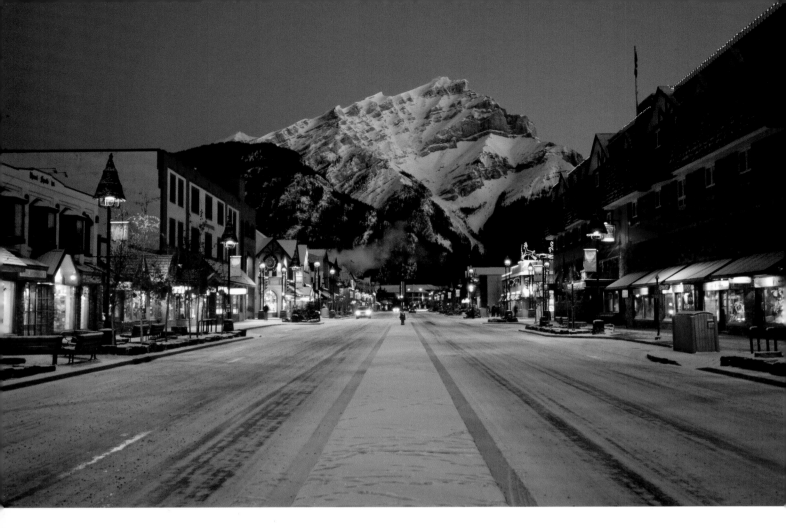

Banff Avenue looks just as beautiful on a calm winter's night, when shop lights ignite the street, as it does on a bluebird day, offering the opportunity to stroll amidst the stillness without any crowds.

Elk, or wapiti, are large ungulates native to the Canadian Rockies. Each spring, the males grow antlers – some nearly four feet long – which are shed in winter.

In Banff Upper Hot Springs, you can soak in the naturally flowing thermal waters. Open year-round, the outdoor pool deck offers breathtaking views of Mt. Rundle.

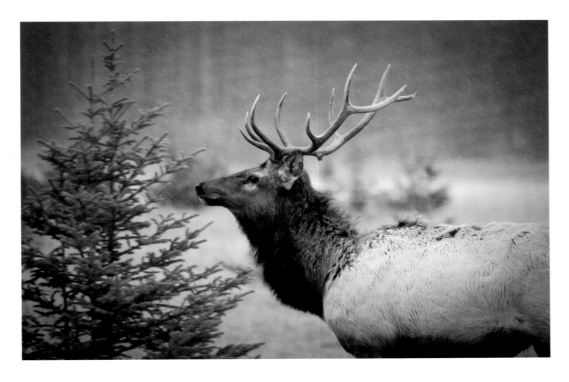
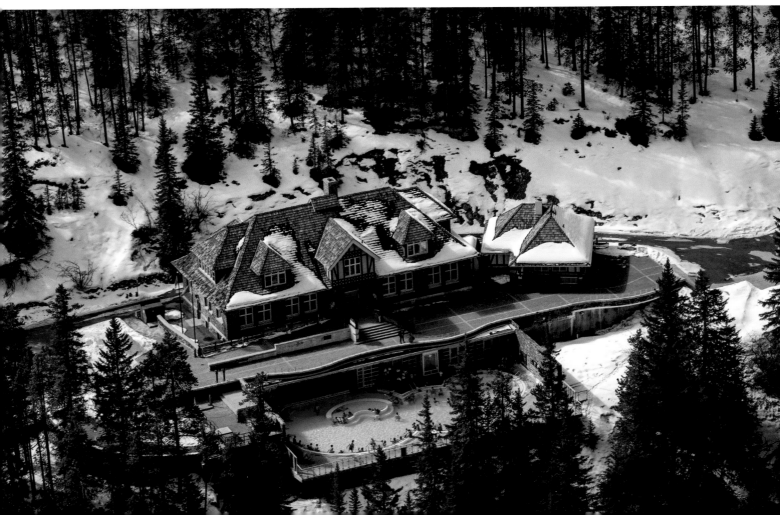

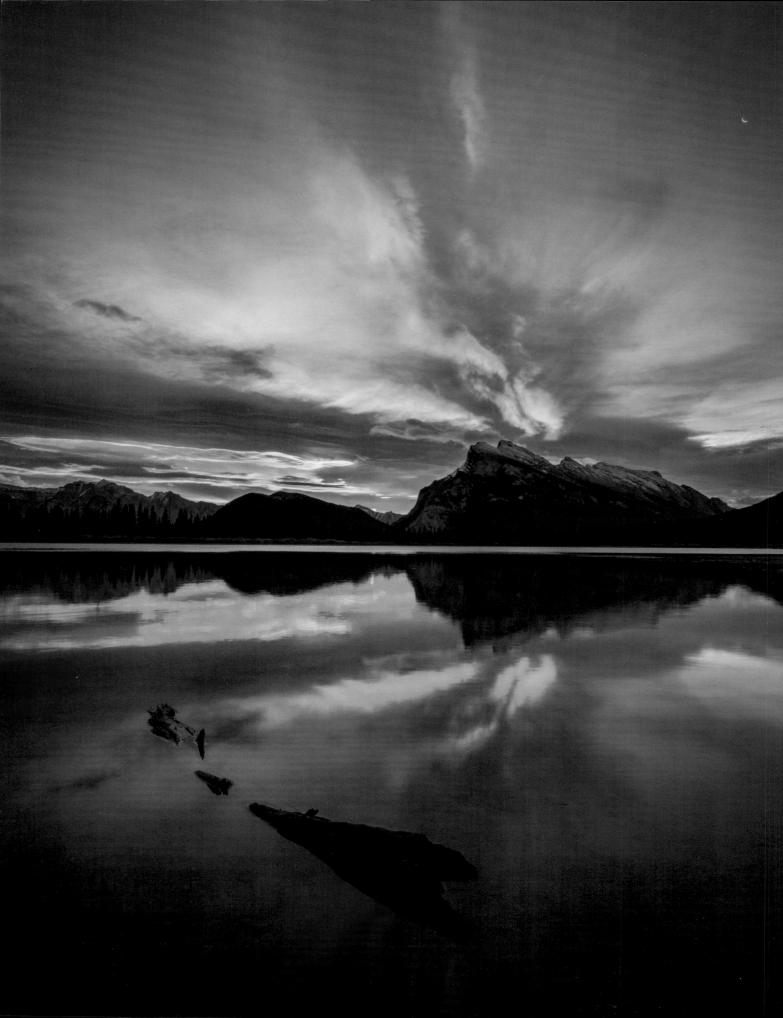

Banff National Park

As Canada's very first national park, Banff has been on the bucket lists of travellers since its inception in 1885. The first tourists came by train, attracted to the thermal waters and the illustrious Canadian Pacific hotels; nowadays millions of tourists pass through the gates each year and explore the park by foot, bike, car and bus.

At 4481 square kilometres, Banff National Park contains many areas of complete wilderness as well as more accessible sightseeing spots, allowing visitors of all kinds to enjoy the stunning landscapes that have put this park on the world stage.

The sky bursts with colour as the sun rises over Vermilion Lakes and the serrated peaks of the 2948-metre-high Mt. Rundle. In 1858 John Palliser named the mountain after Reverend Robert Rundle, a Methodist minister who came to the Bow Valley as a missionary in the 1840s.

Lake Minnewanka (Stoney for "water of the spirits") is flooded with history – literally. Now the largest lake in Banff National Park, Minnewanka has been dammed twice, and in 1941 submerged a town called Minnewanka Landing. The waters are said to be haunted, hence the name. It is one of the only lakes in the Canadian Rockies that allows for commercial motorized boats; the Lake Minnewanka Boat Cruise (pictured here at centre) provides views of the surrounding peaks.

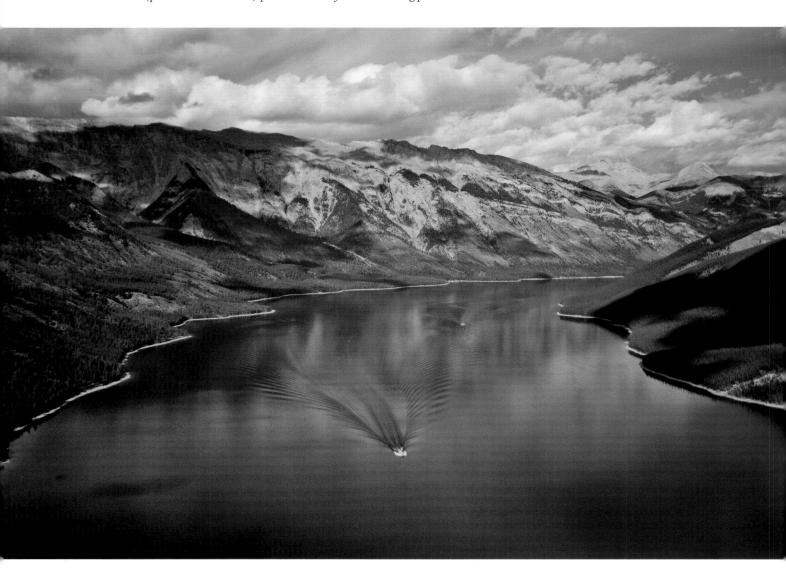

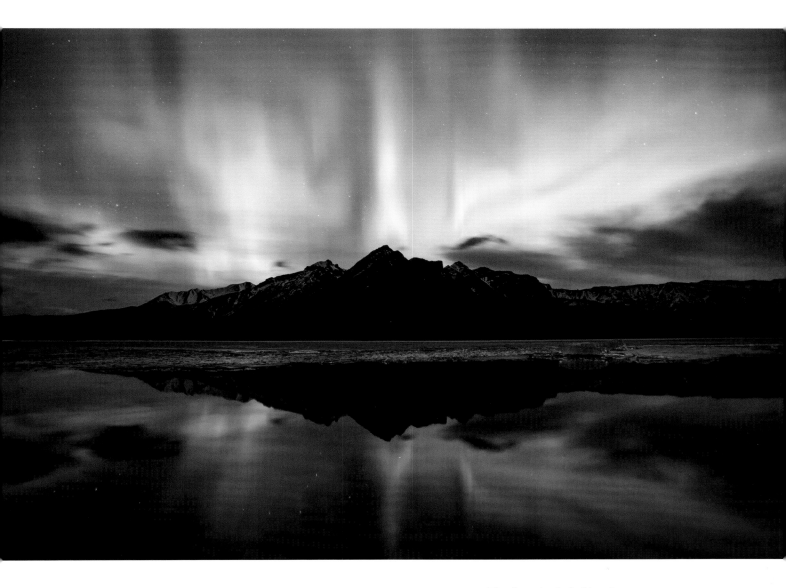

Thanks to the dark skies of Banff National Park, the aurora borealis, or northern lights, can frequently be seen from areas with north-facing views, such as Lake Minnewanka.

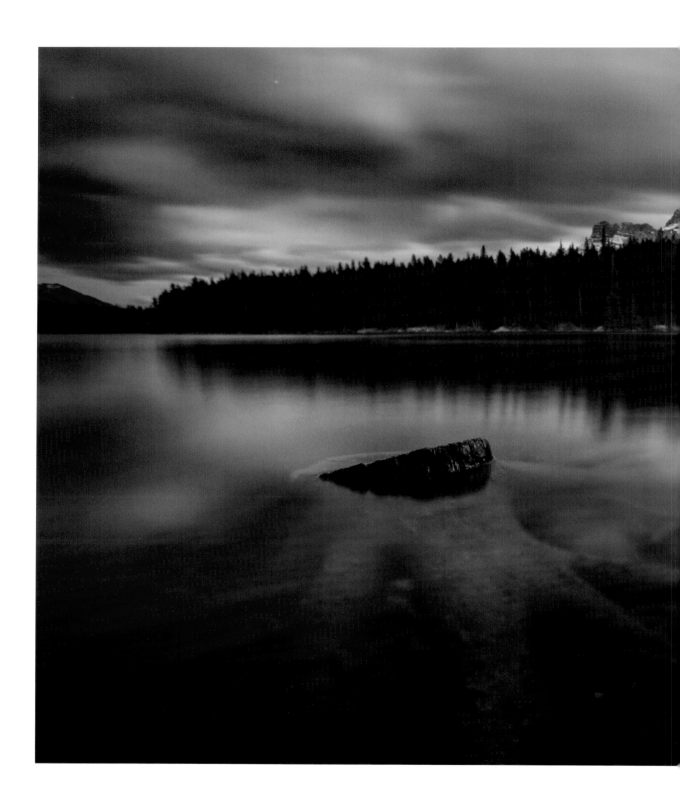

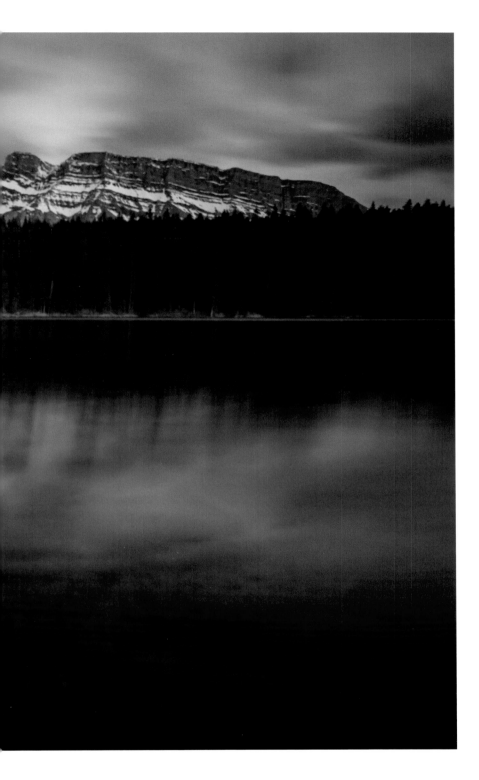

Evening sets in at Johnson Lake. This popular recreational area close to the town of Banff offers hiking, swimming and paddling in summer and, if you get there when the conditions are right, a memorable skating rink in wintertime.

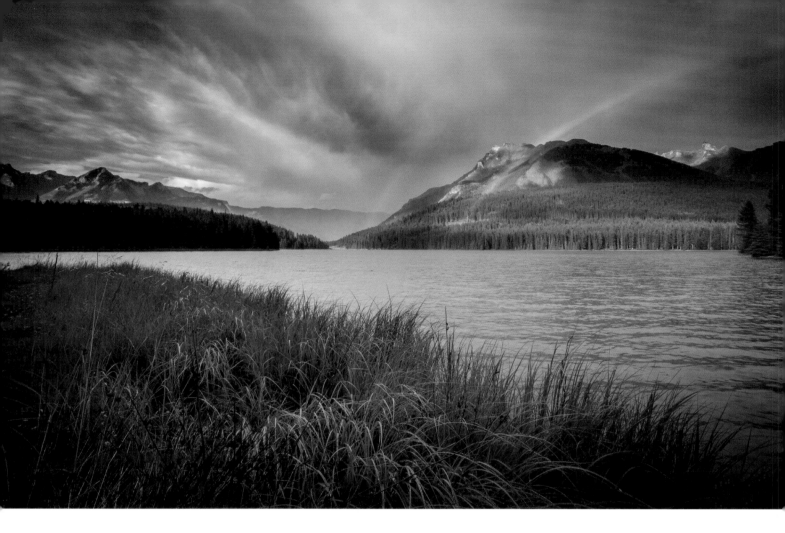

ABOVE *A double rainbow graces the sky at Two Jack Lake, named after two men who lived and worked in the Banff area in the early 20th century: Jack Standly, the boat operator at Lake Minnewanka, and Jack Watters, who worked in the mines at nearby Bankhead.*

OPPOSITE ABOVE *An eagle soars amidst the rocky peaks at Taylor Lake, Banff National Park.*

OPPOSITE BELOW *Mountain dwellers look forward to the appearance of the prairie crocus, one of the first flowers to emerge in springtime.*

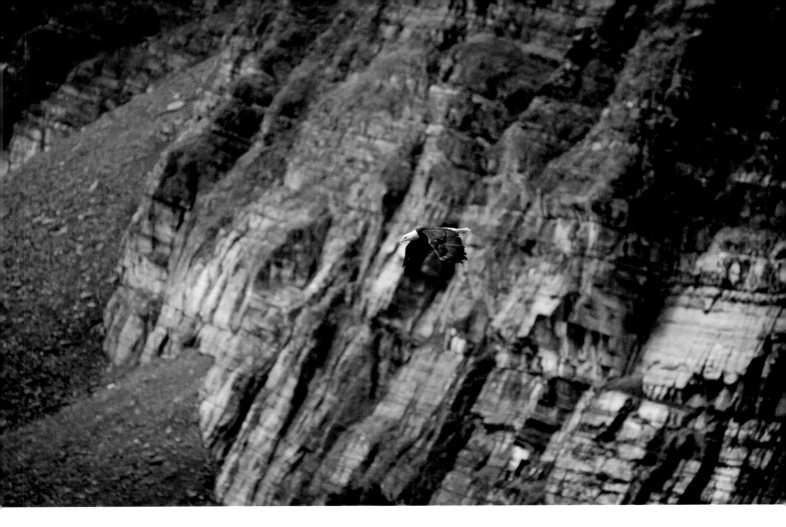

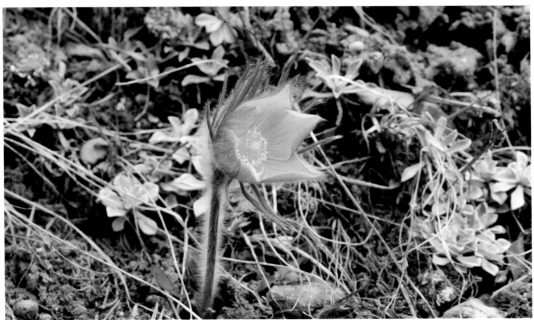

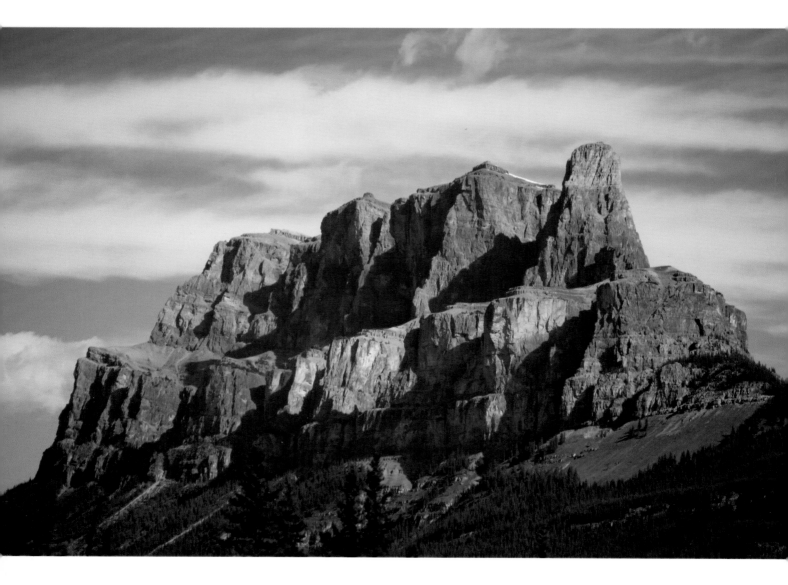

Named for its shape, 2766-metre-high Castle Mountain was formed as weak layers of shale eroded over the course of centuries, leaving behind more resistant limestone towers. In 1946, its name was changed to Mt. Eisenhower, in honour of the American general. The original name was restored in 1979 due to public pressure, though one of its pinnacles was named Eisenhower Tower.

At Johnston Canyon, one of the most popular locations in Banff National Park, you can hike interpretive walkways – some built right into the canyon walls – to the base of two waterfalls, the Upper and Lower Falls, pictured here.

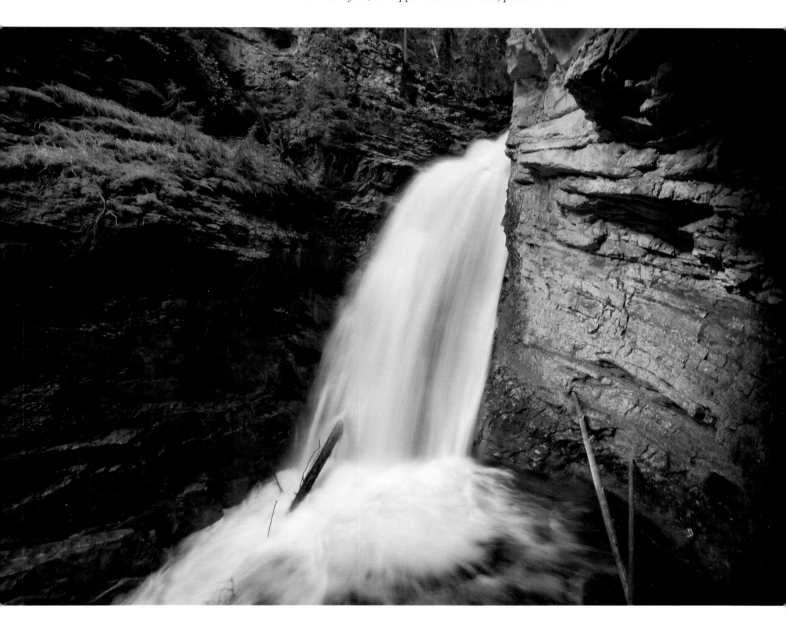

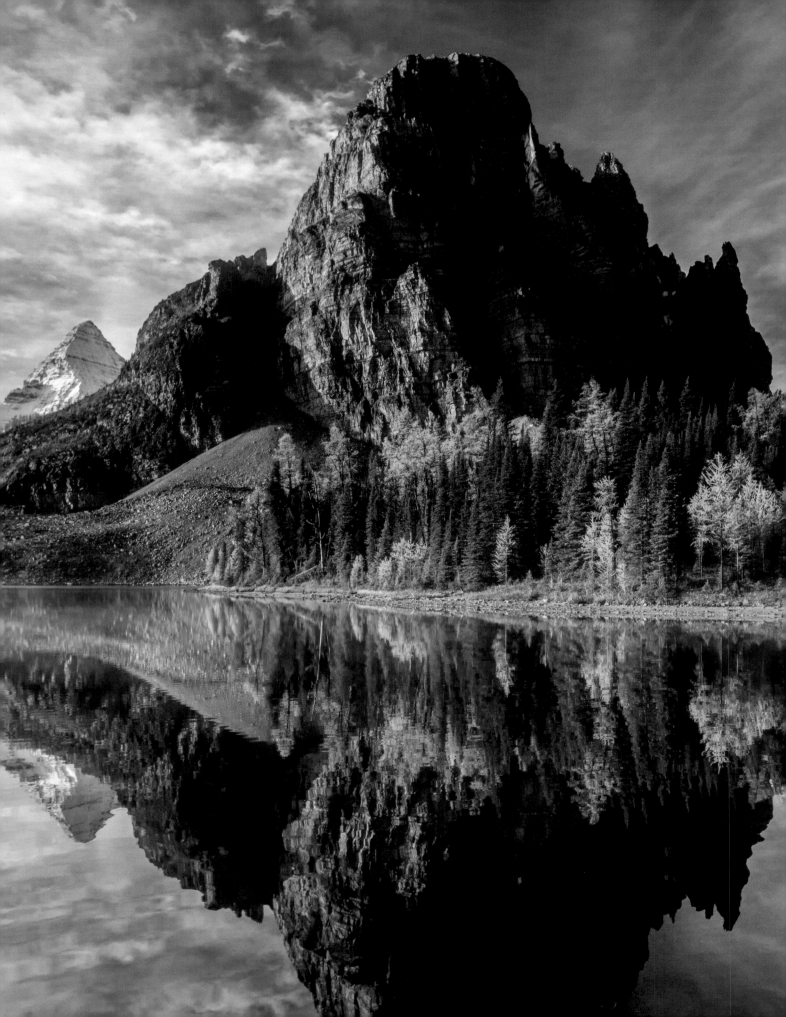

Kananaskis Country and
Mt. Assiniboine Provincial Park

While the mountain parks like Banff and Jasper shine on the world stage, the provincial parks of the Canadian Rockies deserve equal acclaim. Located in the front ranges of the Canadian Rockies, Kananaskis Country is made up of a number of provincial parks and was established in 1977 as a place for recreation, resource extraction and tourism, with efforts made to protect the watershed of the region. You can discover this area's unique beauty through camping and hiking or by exploring the many winter trails on snowshoes or skis.

Nearby is Mt. Assiniboine Provincial Park, established in 1922 and located on the border of Banff and Kootenay national parks. The park's namesake peak towers well above the others in the region, and its triangular summit is easily recognized from many kilometres away. The park offers some of the best backcountry terrain in the Rockies, drawing visitors on foot, ski or helicopter throughout the year.

One of the most photographed locations in Mt. Assiniboine Provincial Park, Sunburst Peak was first climbed in 1910 by T.G. and Katherine Longstaff, guided by the legendary Rudolph Aemmer.

Evening sets in at Mt. Engadine Lodge. Built in 1987, this unique mountain lodge is the only one of its kind in Spray Valley Provincial Park.

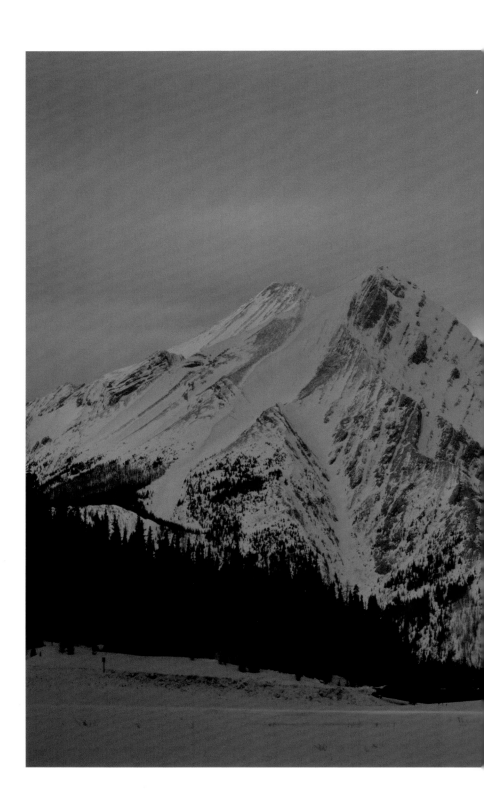

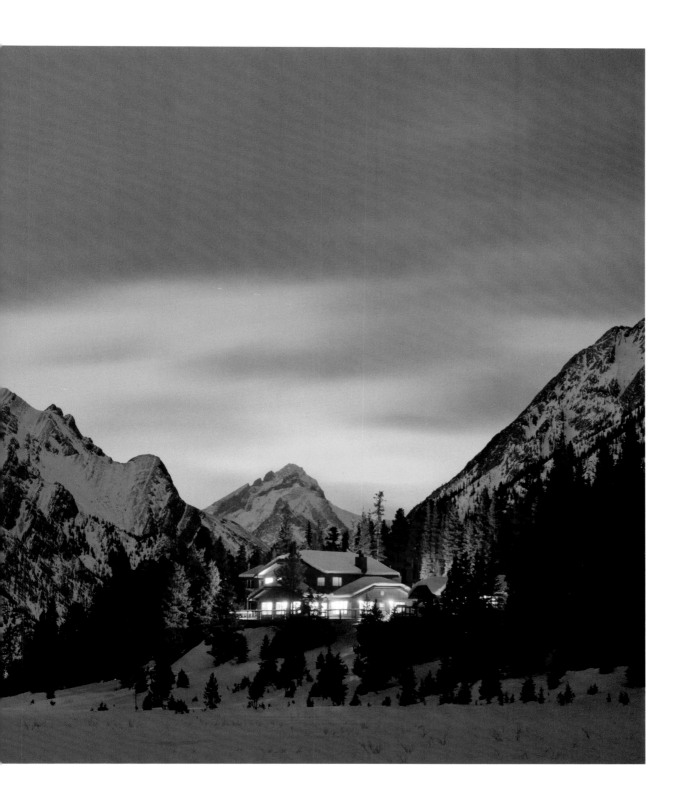

ABOVE Quickly recognizable for its bright yellow flowers, arnica blooms every other year in montane and subalpine regions of the Canadian Rockies.

OPPOSITE The Three Sisters, near Canmore, were named by Albert Rogers in 1883. When he awoke in his tent after a heavy snowstorm, he looked up at the peaks and thought they looked like three nuns; subsequent maps changed "nuns" to "sisters." The peaks are known individually as Faith (Big Sister), Hope (Middle Sister) and Charity (Little Sister).

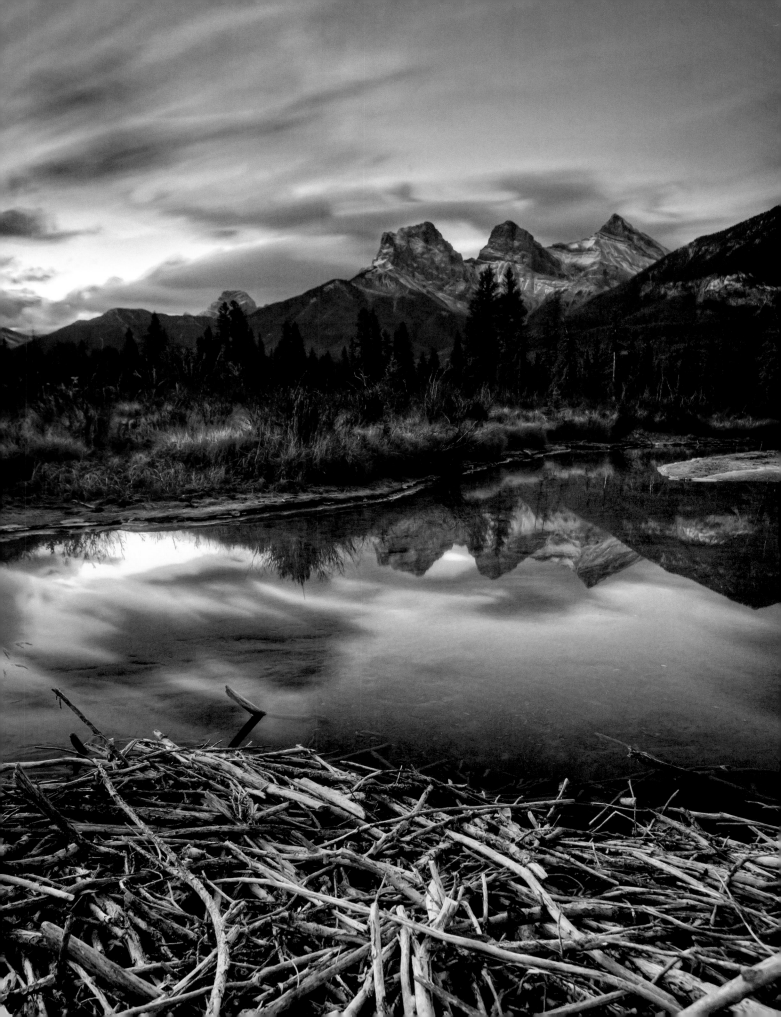

An alpenglow illuminates the shoulder of Mt. Birdwood, a prominent peak that sits on the border of Kananaskis Country and Banff National Park.

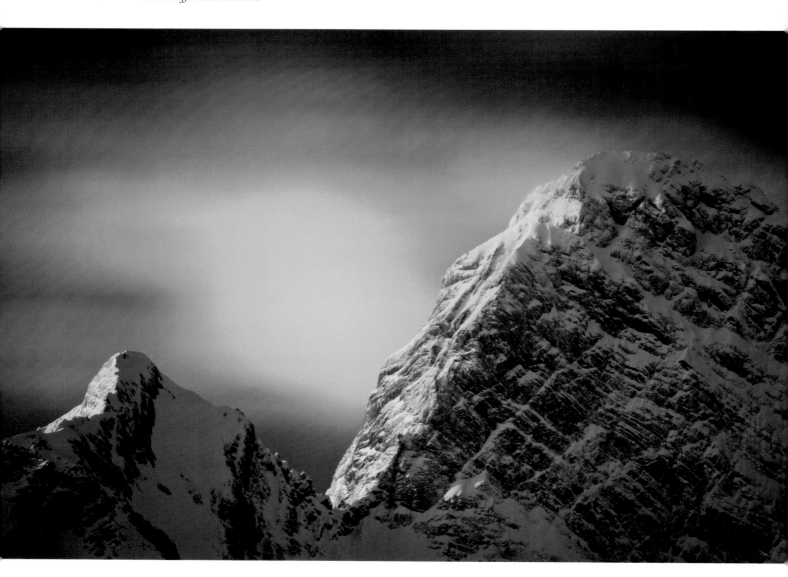

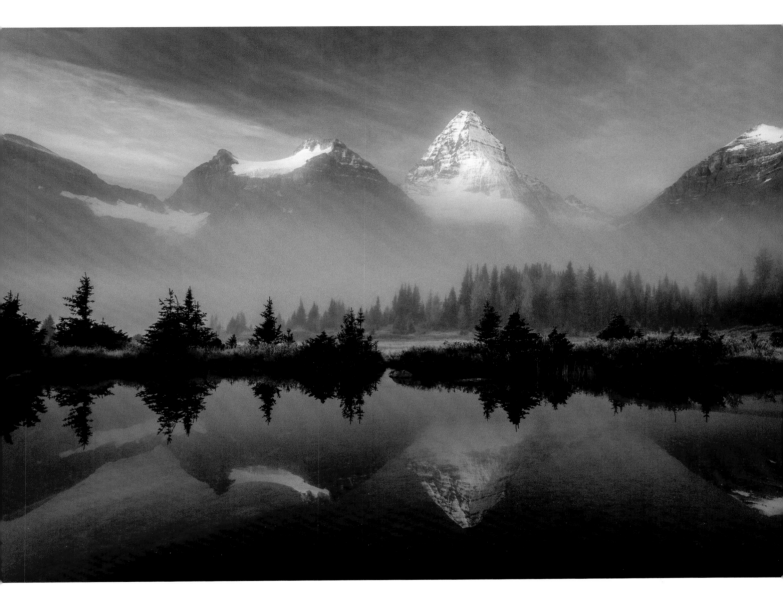

Nicknamed the "Matterhorn of the Rockies" for its resemblance
to the iconic peak in the Alps, Mt. Assiniboine (3618 metres) is
the highest peak in the southern Canadian Rockies. It was named
in 1885 by George Dawson, who was inspired by the plume of
cloud often seen floating off the summit, which reminded him off
the smoke coming from the teepees of the Assiniboine people.

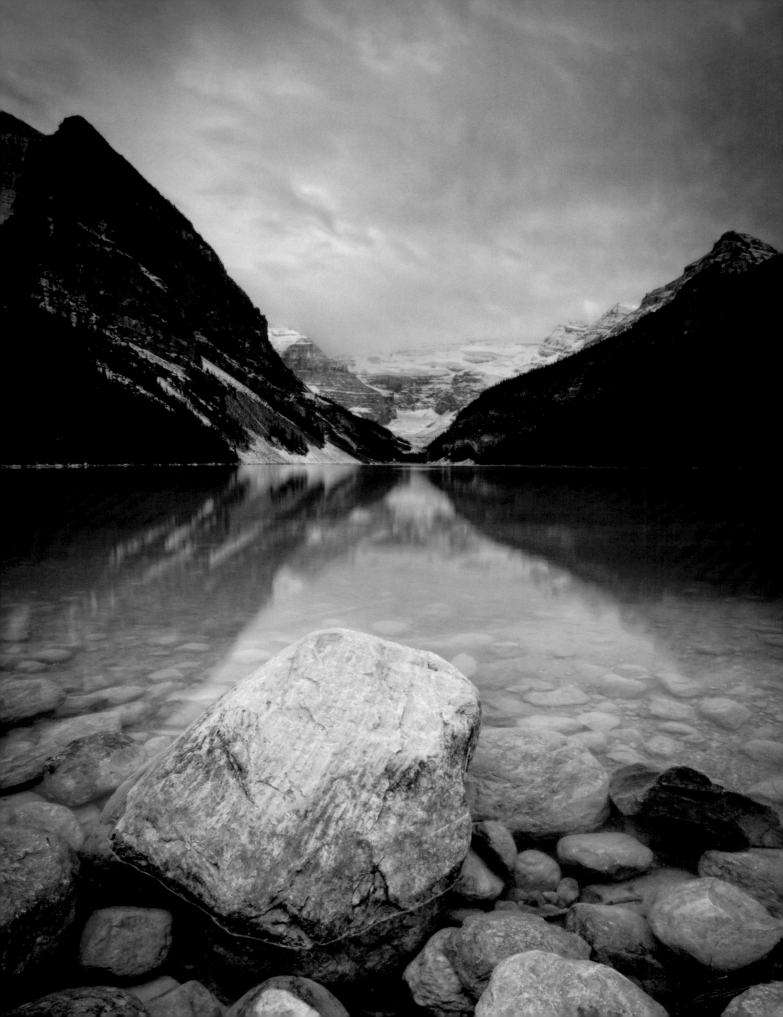

Lake Louise Region

Perhaps the most famous part of Banff National Park is the exquisite Lake Louise region. Named in 1884 after Princess Louise Caroline Alberta, the fourth daughter of Queen Victoria, the lake has carried a few names in its history. It was called Ho-Run-Num-Nay ("lake of the little fishes") by the Stoneys well before Tom Wilson became the first non-Native to set eyes on it. Guided by Edwin Hunter, a Stoney man, Wilson reached the shores of the lake in 1882 and named it "Emerald Lake" after its emerald-hued water (a name that he later applied to Emerald Lake in Yoho National Park).

The Lake Louise region boasts an exciting history as one of the birthplaces of mountaineering in the Rockies. It all centred around lodging built by the Canadian Pacific on the shores of the lake as a way of bringing tourists and alpinists deeper into the mountains along the rail line. What began as a small, single-level cabin with beds for 12 guests has now become the luxurious Fairmont Chateau Lake Louise.

Moraine Lake is not far from Lake Louise in either distance or fame. It features some of the region's most iconic mountains, including the Ten Peaks that make up the postcard-perfect view together with the impossibly blue waters of the lake itself.

Lake Louise is a popular location for sightseeing year-round; in summer, its open waters show a dramatic shade of turquoise.

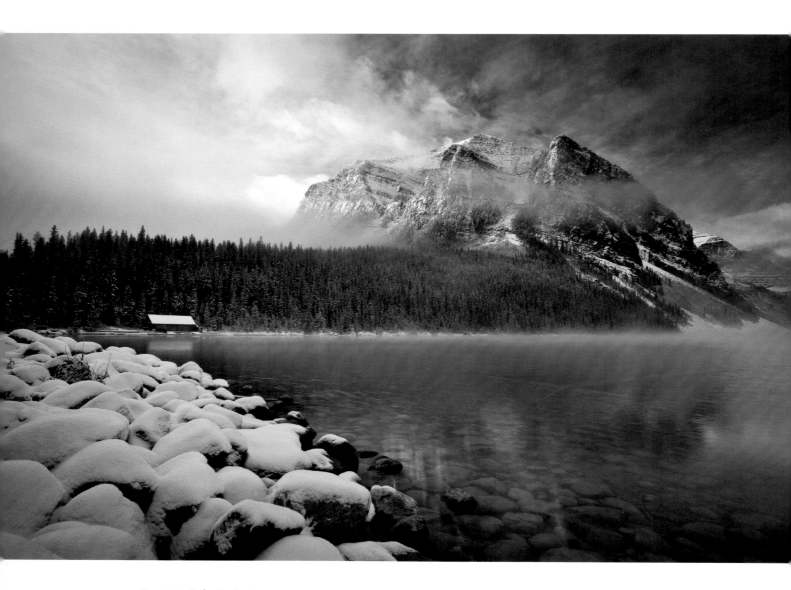

In winter, Lake Louise transforms under a blanket of snow. The lake itself freezes, creating what is quite possibly the most scenic skating rink in the world.

Viewed here from the sky, the
Fairmont Chateau Lake Louise
and surrounding properties
can be seen at their enviable
lakeside locations. The glaciated
peak is Mt. Victoria, named
by surveyor J.J. McArthur in
honour of Queen Victoria.

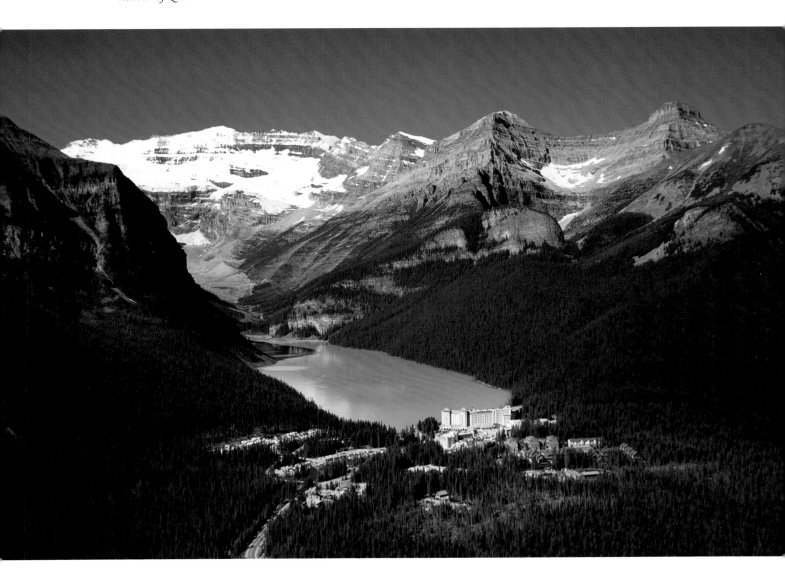

Located at an altitude of 2925 metres, the Abbot Pass Hut is the second-highest habitable structure in Canada. It was built in 1922 by Swiss mountaineering guides working for the Canadian Pacific Railway as a refuge for climbers. The pass and hut were named after Philip Stanley Abbot, who fell to his death on Mt. Lefroy in 1896 – the first mountaineering casualty in North America. The hut is now operated by the Alpine Club of Canada.

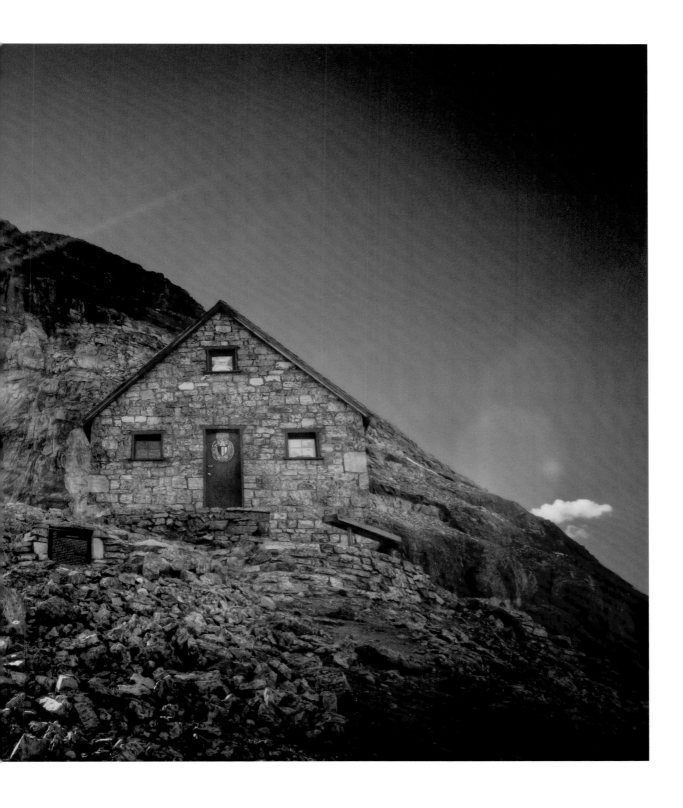

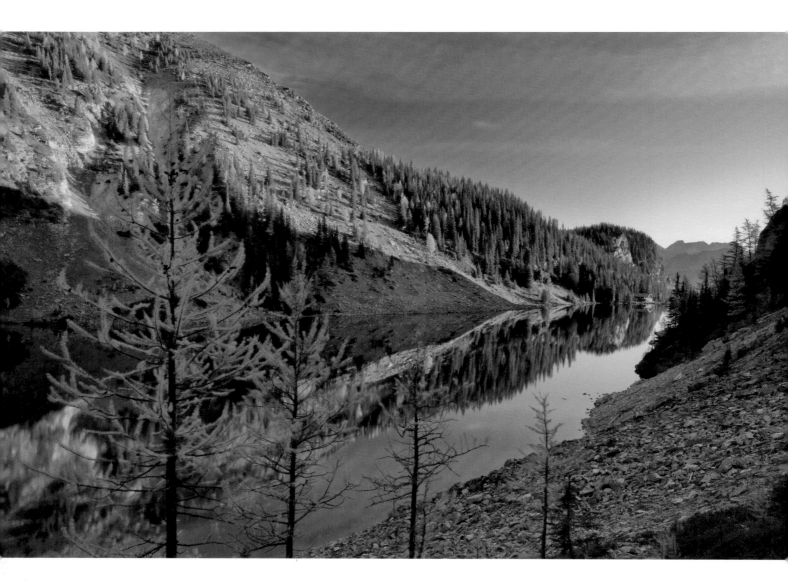

Lake Agnes was named after Lady Agnes Macdonald, the wife of
Canada's first prime minister. Originally built as a hiker's refuge by
the Canadian Pacific Railway in 1901, the Lake Agnes Tea House
still operates today. Hikers can make the 3.5-kilometre trek to the tea
house to enjoy loose leaf teas, soup, sandwiches and baked goods.

Built by the Canadian Pacific Railway between 1924 and 1927, the Plain of Six Glaciers Tea House was originally constructed to house mountaineers en route to the popular objectives of Mts. Victoria and Lefroy. Hikers today can enjoy a menu of fresh lemonade, tea, pie, scones and more.

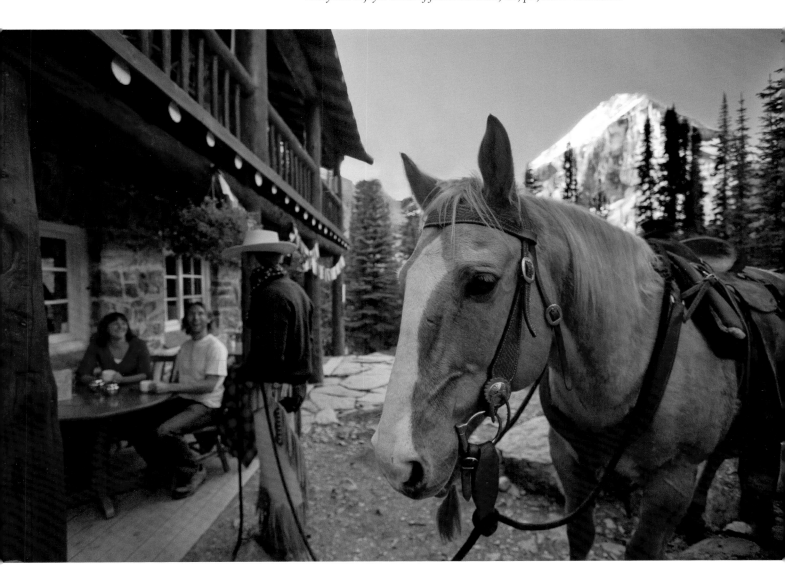

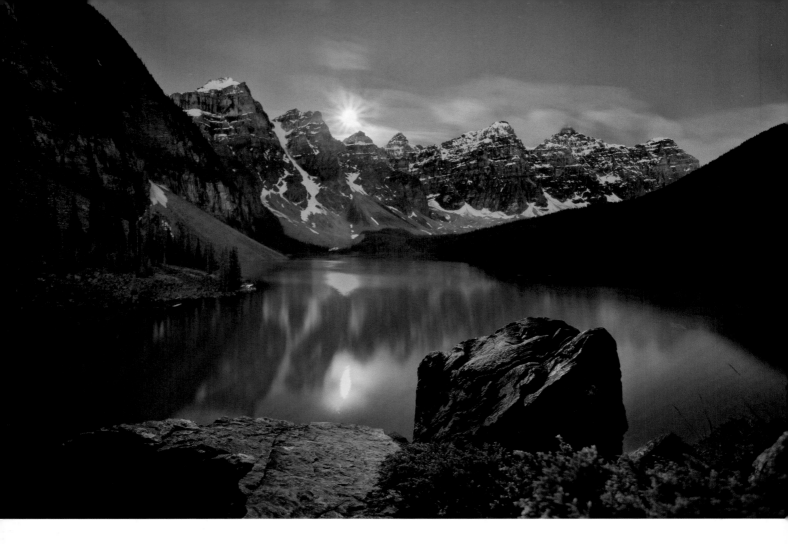

ABOVE *The moon rises at Moraine Lake, one of the most well-known locations in the Canadian Rockies. The famous skyline is punctuated by the Ten Peaks, which were once named after the Stoney words for numbers one through ten (now three retain their Stoney names while others have been changed to the names of noteworthy individuals).*

OPPOSITE ABOVE *Skoki Lodge first opened its doors to back-country skiers in 1931 and was designated a National Historic Site in 1992. Now a sought-after destination for skiers and hikers alike, the lodge's guestbooks reveal many noteworthy names and Rockies legends who have visited over the years.*

OPPOSITE BELOW *A noteworthy peak in the Lake Louise region, Mt. Temple is easily recognized by its triangular, glaciated summit. At 3544 metres high, it presents various routes of ascent and is a popular objective for mountaineers and ambitious hikers.*

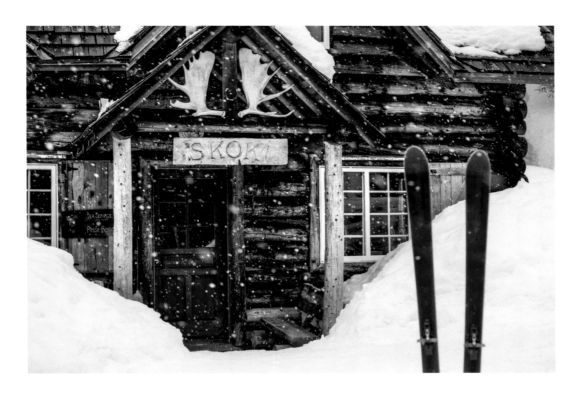

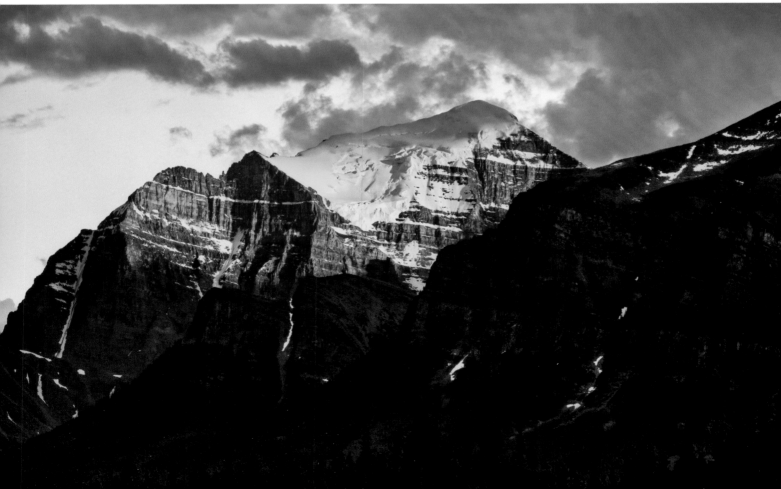

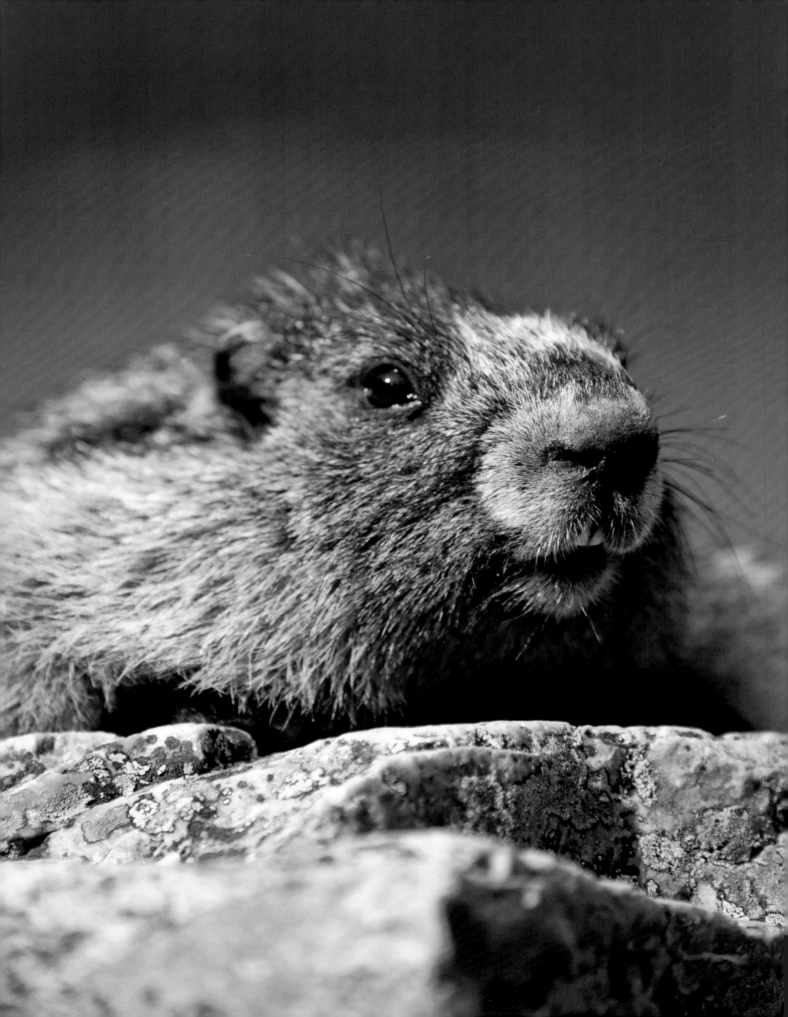

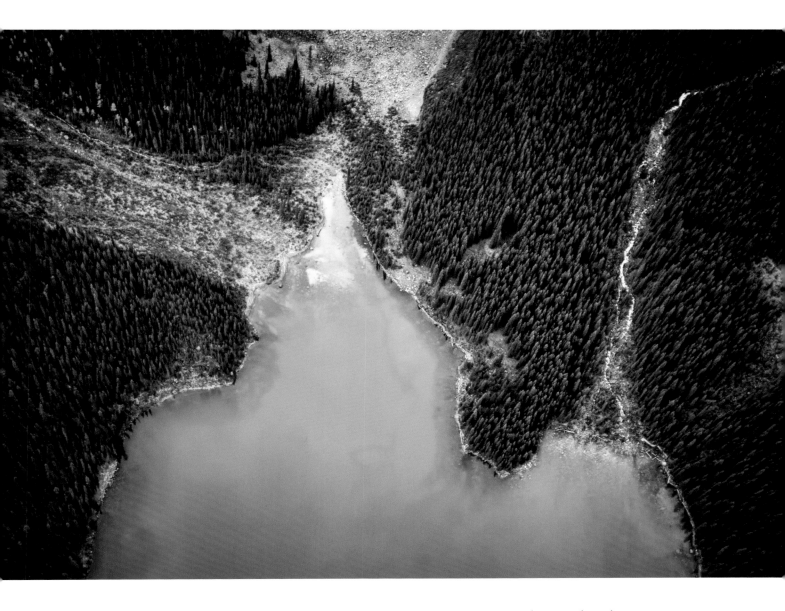

OPPOSITE *A common resident
of alpine regions, the hoary
marmot is often heard before it
is seen, thanks to its distinctly
long and high-pitched whistles.*

ABOVE *This unusual aerial
perspective of Moraine Lake
shows its dramatic colour. Lakes
throughout the Canadian Rockies
are world-famous for their vibrant
blue-green hues, which result from
glacial silt in the water reflecting
those particular colours of light.*

53

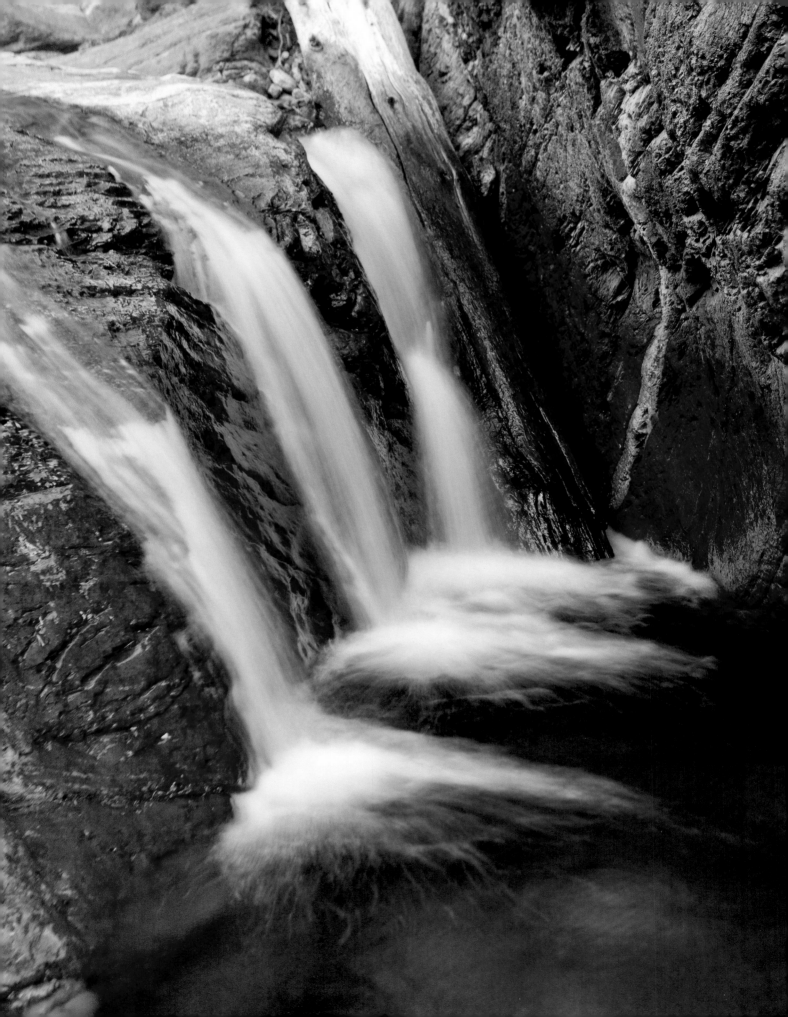

Waterton Lakes National Park

At just 505 square kilometres, Waterton Lakes National Park is the smallest of the mountain national parks but, as part of the Crown of the Continent ecosystem, it has a unique geology and biological diversity.

Created in 1895, Waterton Lakes possesses the oldest sedimentary rock in the Canadian Rockies, which dates back 1.5 billion years, and has more wildflower varieties than any other location in Canada. It is also home to one half of the Waterton-Glacier International Peace Park, which since its creation in 1932 has facilitated the shared management of the ecosystems within both parks, across the Canada–US border. Hop on a boat ride down Waterton Lakes and you'll actually be taken across that border and into the United States, where a small museum pays tribute to the peace and goodwill between the two countries.

Red Rock Canyon is one of the most striking features in Waterton Lakes National Park. Its colour comes from iron-rich shales that, when oxidized, turn a bright shade of red.

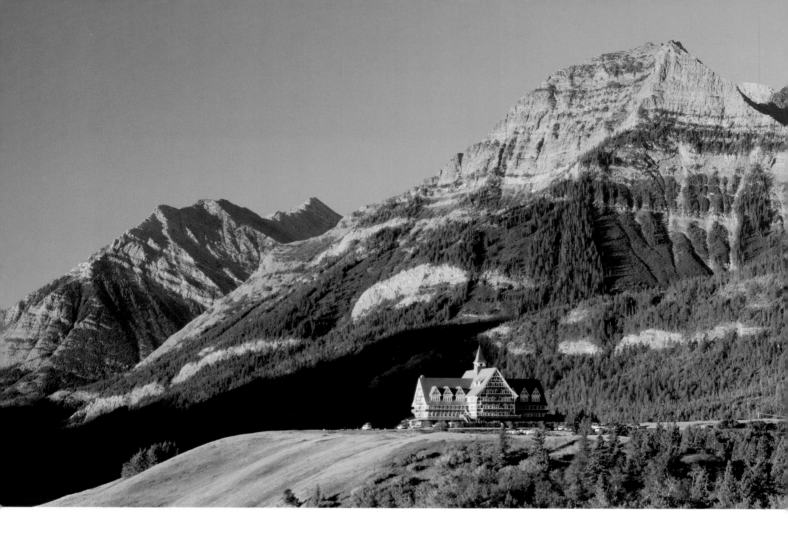

ABOVE *The Prince of Wales Hotel has an illustrious placement on a hillside overlooking Upper Waterton Lake. Unlike any other grand railway hotel in the Canadian Rockies, the Prince of Wales was built by an American railway, the Great Northern, in 1926–27, as a stop for affluent travellers en route to nearby Glacier National Park. It was designated a National Historic Site in 1995.*

OPPOSITE ABOVE *As you enter Waterton Lakes National Park, the change in topography is extreme. With no intervening foothills, you move from the flattest of plains to mountainous terrain in just a short drive.*

OPPOSITE BELOW *From the Bear's Hump, a popular viewpoint close to the Waterton townsite, you can take in a phenomenal view of the lakes that make this park so famous. Waterton is also known for its gale-force winds, which funnel through this valley on a nearly daily basis.*

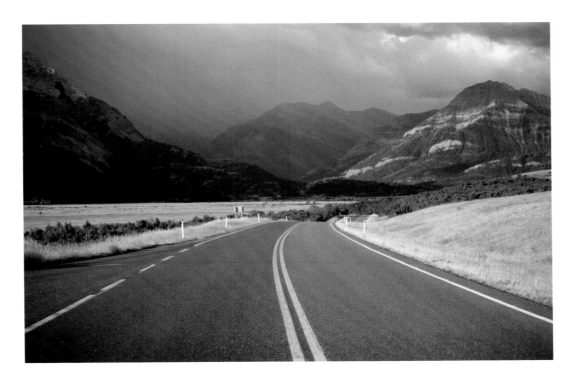

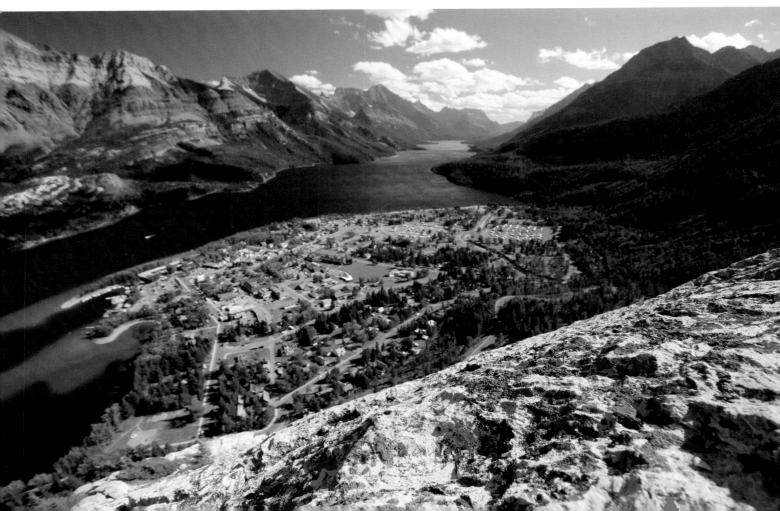

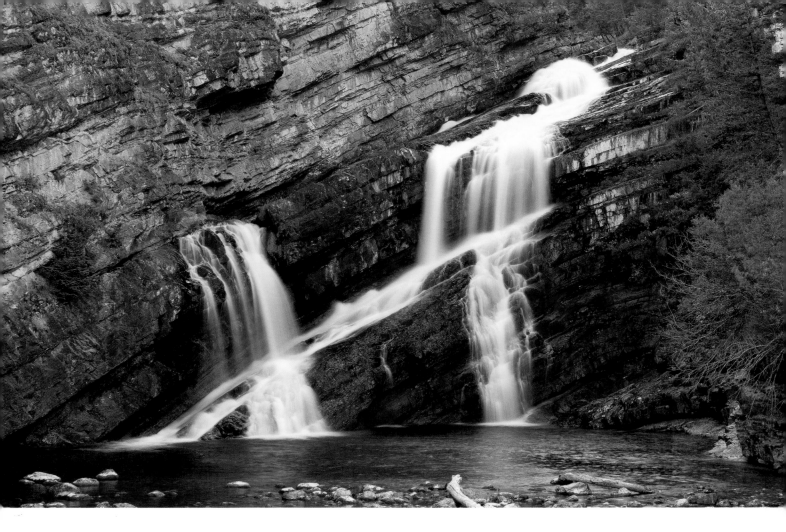

ABOVE *At Cameron Falls, one of Waterton's most photographed landmarks, water cascades over 1.5-billion-year-old Precambrian rock – the oldest rock in all of the Canadian Rockies.*

OPPOSITE ABOVE *Easily recognized for their curved horns (in males), the Rocky Mountain bighorn sheep are wonderful to look at but a force to be reckoned with. Large males can weigh up to 500 pounds!*

OPPOSITE BELOW *One of the most beautiful wildflowers found in the Canadian Rockies, the calypso orchid grows in shaded forest areas.*

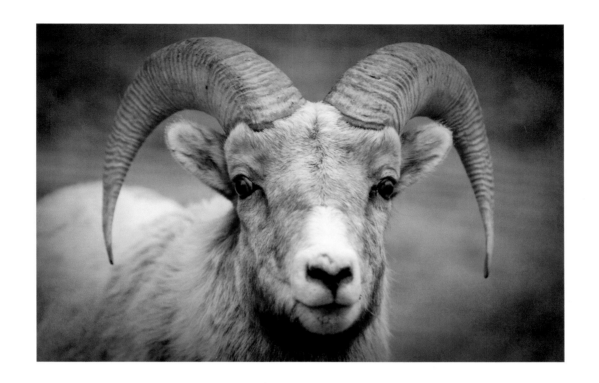

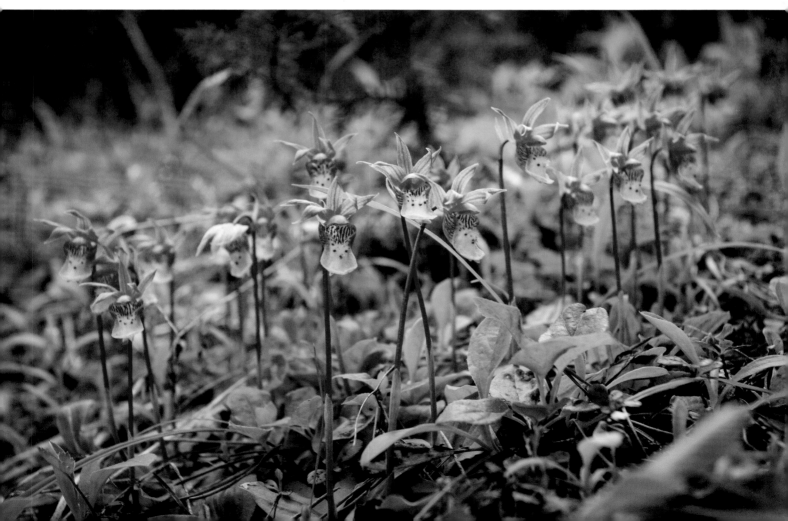

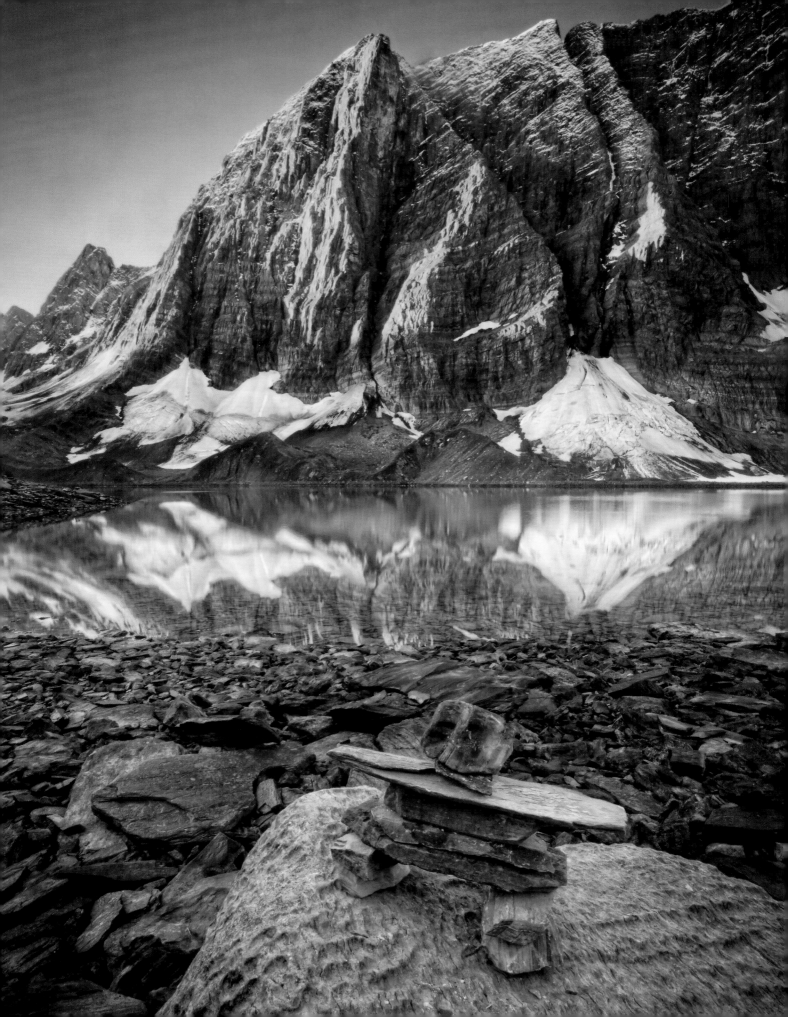

Kootenay National Park

Kootenay National Park has its own unique charm, with rugged peaks and bubbling hot springs, deep canyons and alluring backcountry terrain. An often overlooked wonder of the Canadian Rockies, Kootenay was established in 1920 as part of an agreement between the federal government and the Province of British Columbia to build a new road through the Rockies. Land on either side of the highway was set aside as a national park that borders Banff and Yoho.

The recent history of the park is marked by a 2003 wildfire that engulfed over 17,000 hectares of forest. Wildfires are healthy for a forest's ecology, but they can endanger towns and roadways if they burn out of control. Now a national wildfire strategy includes prescribed burning to prevent large-scale forest fires like that in Kootenay. Even in these burnt areas, keep your eyes peeled for wildflowers growing amidst the charred stumps and deadfall. There is beauty even in a singed forest if you look for it.

A classic of Kootenay National Park, the hike to Floe Lake can be done as a longer day trip, or as part of a multi-day backpacking excursion on the Rockwall Trail.

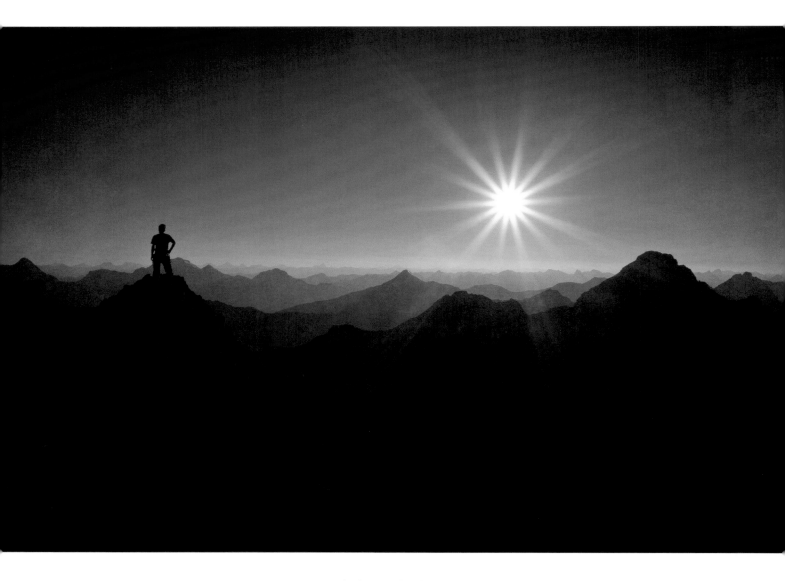

A climber watches the sunset on the Great Divide from the top of Mt.
Neptuak, where three national parks converge: Kootenay, Banff and Yoho.

The 2003 burn that scarred the region reduced many forest areas to blackened, leafless trees. Look down and take time to appreciate that new life is emerging all around.

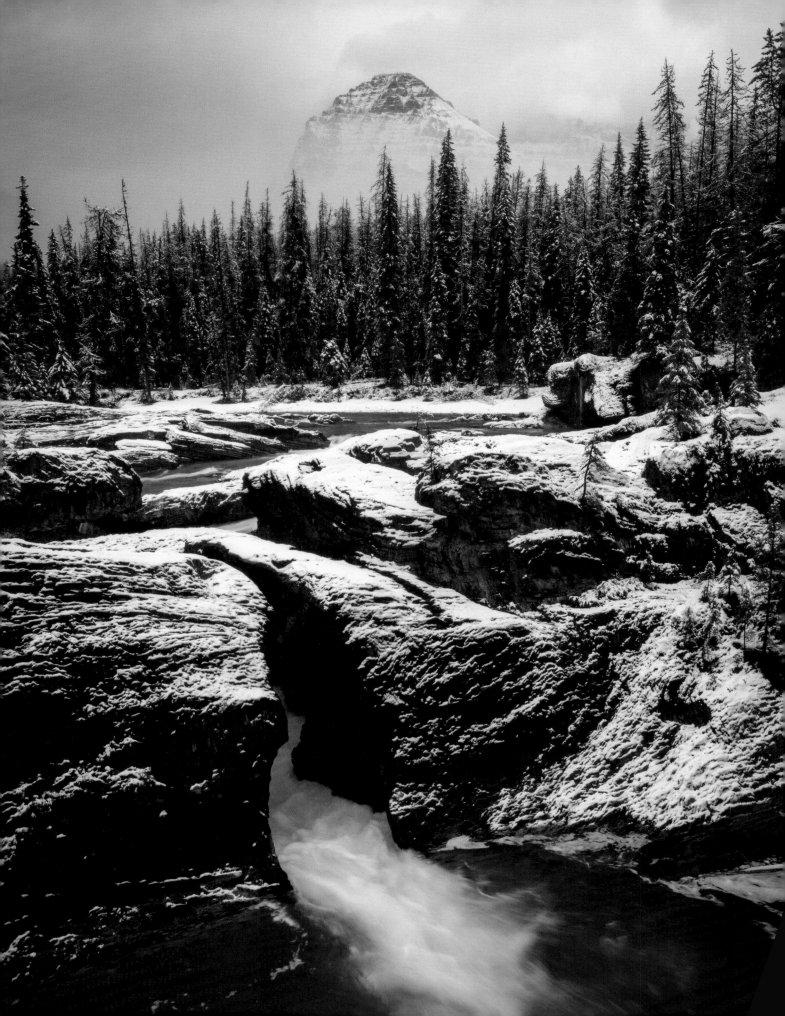

Yoho National Park

The Cree word *yoho* means "wonder and awe" – the perfect name for this remarkable corner of the Canadian Rockies, a favourite spot of many Rockies visitors. Established in 1886, Yoho National Park is home to some of the gems of the region: towering peaks; the thunderous waters of Takakkaw Falls; the hidden secrets of Lake O'Hara; the quaint village of Field. It is here that the Burgess Shale fossil beds, one of the world's most significant deposits of ancient fossils, were discovered in 1909. Today, tourists can take a guided hike to see these rare and highly protected specimens.

While much sightseeing in Yoho National Park can be done from the road, the best way to discover the majestic lakes, lush valleys and surging waterfalls of this wonderland is on foot — whether through a walk around Emerald Lake, a hike at Lake O'Hara or a backpacking trip deep into the Little Yoho Valley.

Yoho's famous Natural Bridge is as exactly as it sounds. It's here that the Kicking Horse River meets an outcropping of limestone, and over the years the water has worn it away by force. Now the water pours through a crack in the rocks and a "bridge" remains over top.

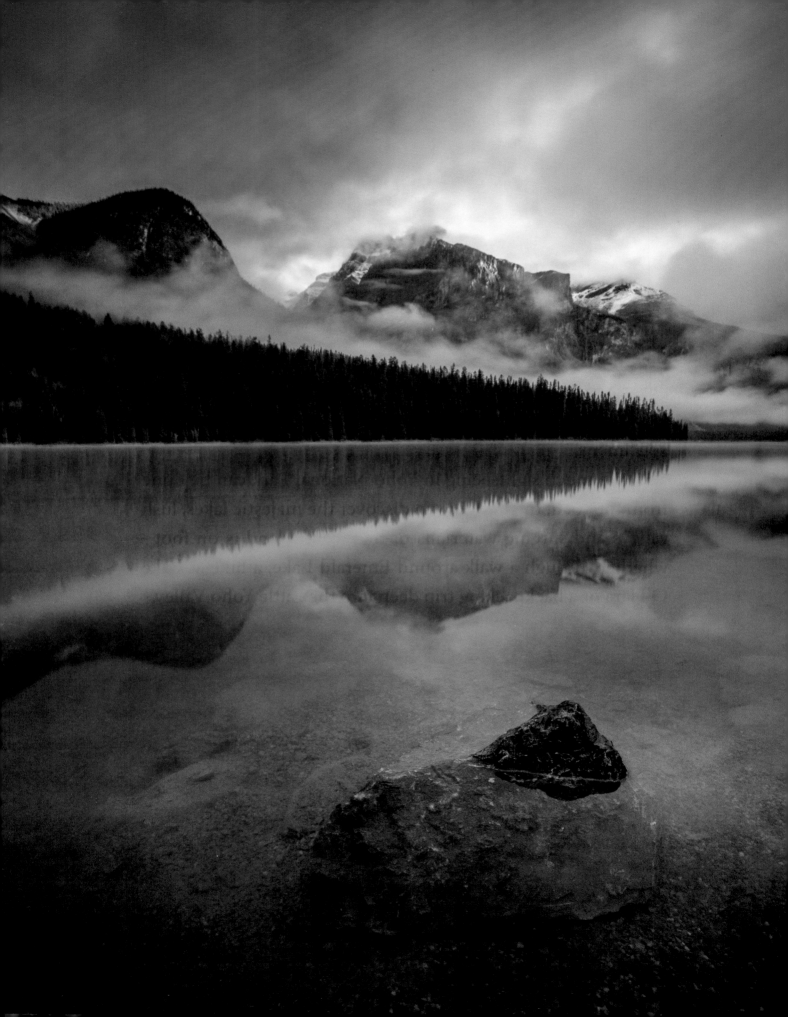

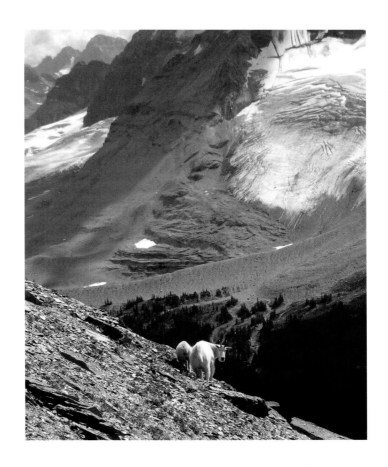

Two mountain goats roam the alpine slopes on the Whaleback Trail, Yoho National Park.

Though it is likely that First Nations peoples had knowledge of or used this lake area in the past, the first non-Native to encounter Emerald Lake stumbled upon it by accident. In 1882, Tom Wilson was chasing an escaped team of horses when he came across the lake. He chose the name because of the green-blue hue of the water.

Fed by the Daly Glacier above, Takakkaw Falls is one of the higher waterfalls in the Canadian Rockies, at 302 metres. Roughly translated, the name means "it is magnificent" in Cree. Here, climbers do a nighttime ascent of the rock wall to the left of the falls.

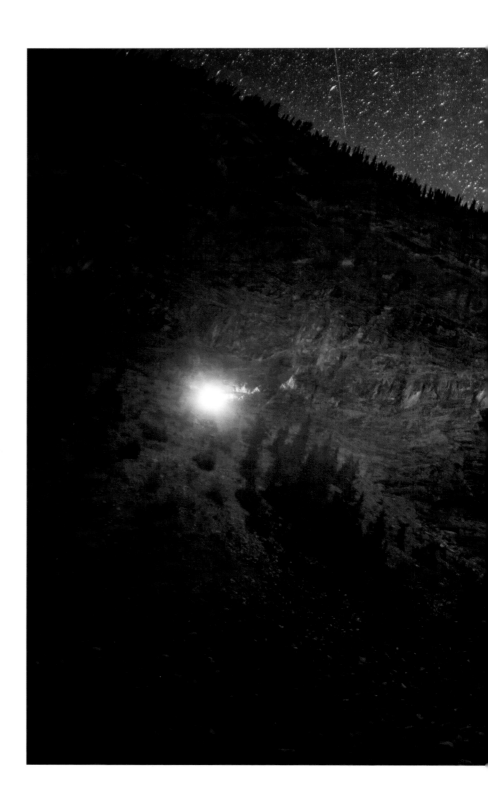

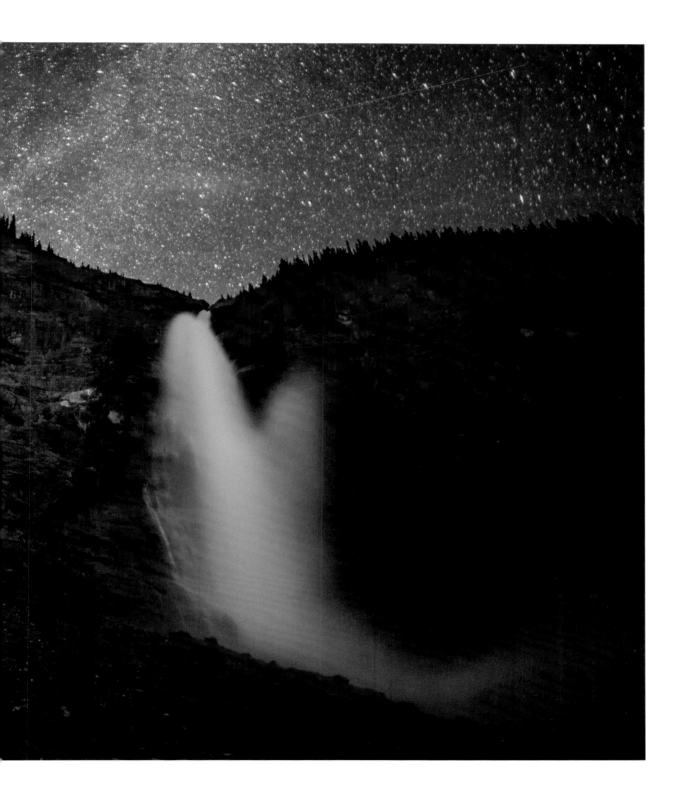

Boasting a prime location on the shores of its namesake, Emerald Lake Lodge was originally built in 1902. The lodge has been renovated in the intervening years, but it retains its historic charm and offers visitors a chance to unwind in a pristine setting.

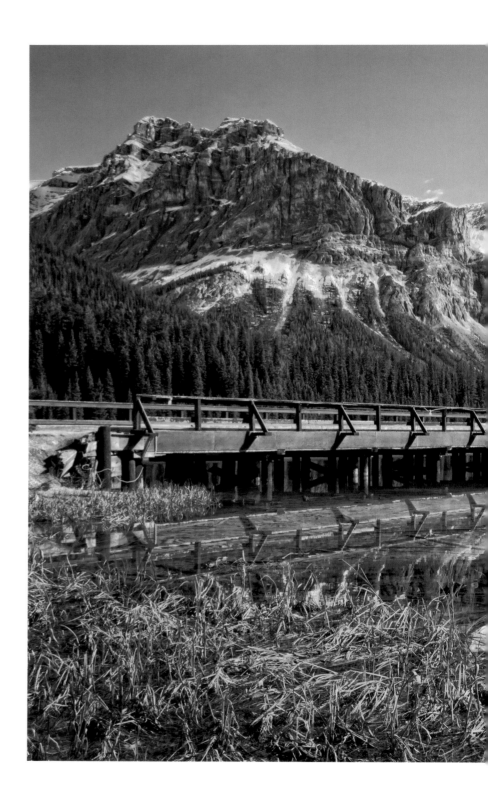

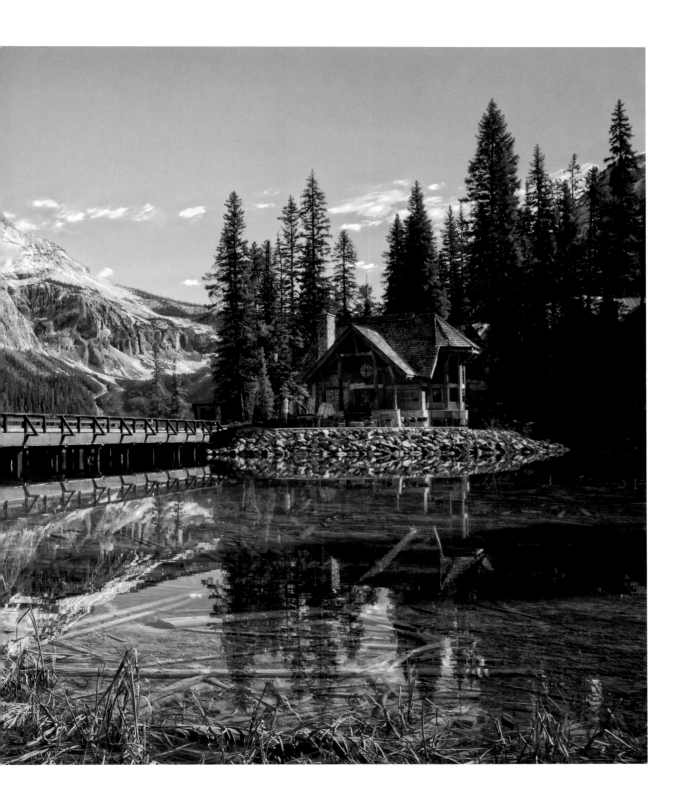

Lake O'Hara's shoreline is dotted by the cabins of Lake O'Hara Lodge, and its famous skyline of peaks rises beyond, including Mts. Huber, Victoria, Lefroy, Yukness and Hungabee. Because the lake is accessible only by bus or a 12-kilometre hike or ski in, it is never crowded. The region boasts one of the best hiking trail networks in the Canadian Rockies.

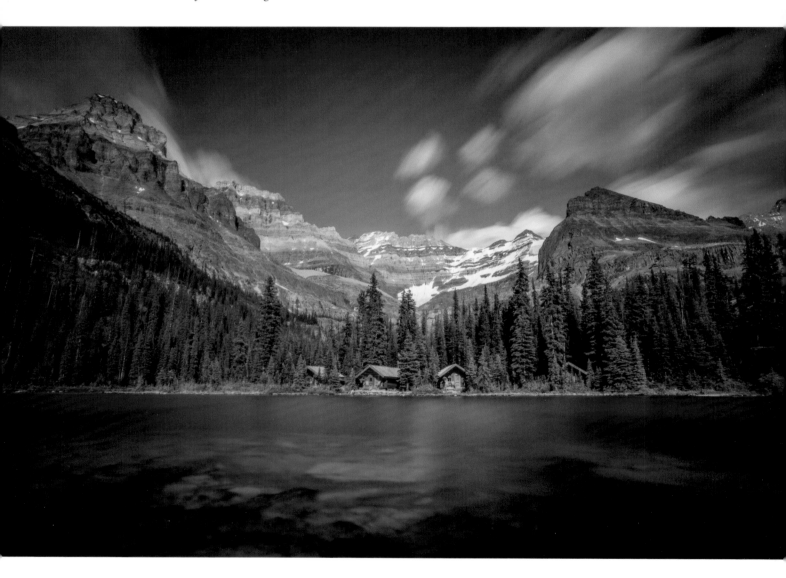

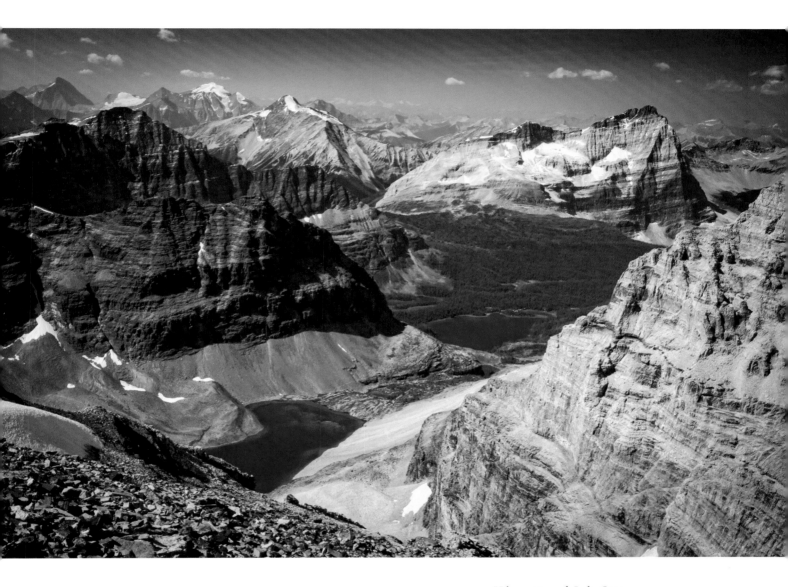

Hikers approach Lake Oesa on the breathtaking Alpine Circuit, a nearly 12-kilometre trail that climbs to lofty views above the Lake O'Hara basin.

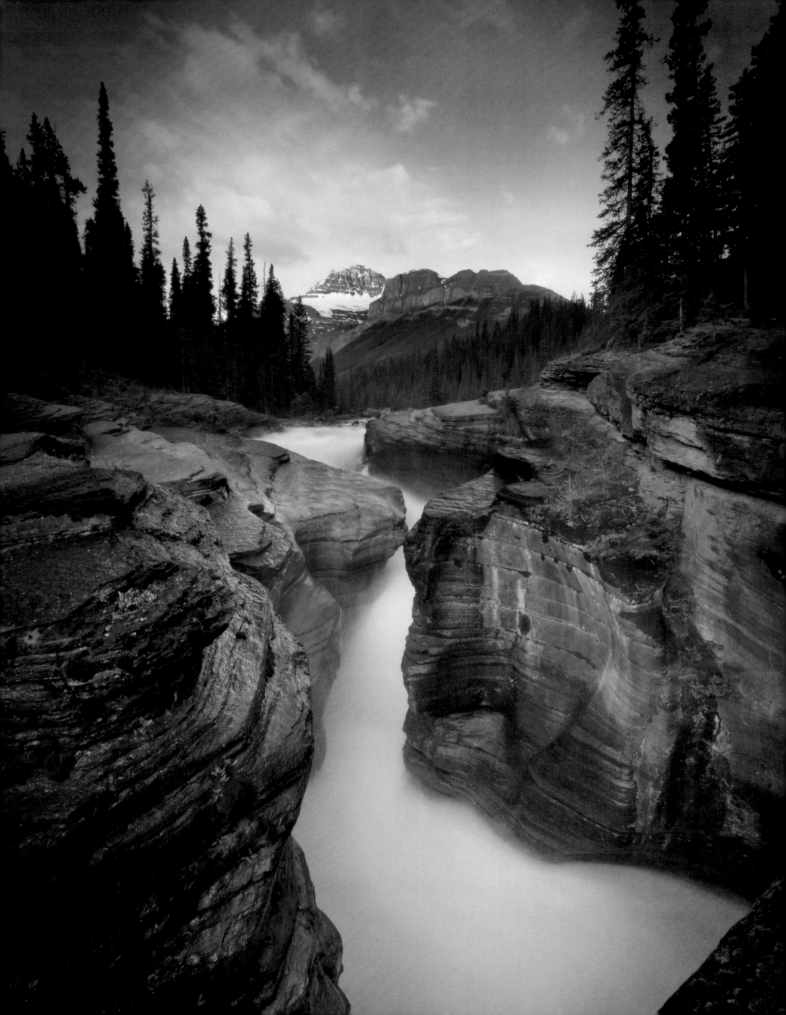

The Icefields Parkway

Rated one of the world's great scenic highways by *National Geographic*, the Icefields Parkway journeys through Banff and Jasper national parks, providing exquisite views of magnificent peaks, impossibly blue alpine lakes and impressive glaciers. Driven non-stop, the road takes only about three hours, but many visitors take the whole day to explore the lakes, scenic stops and waterfalls along the way.

The Icefields Parkway can be enjoyed year-round, though most amenities along the way are closed in winter. In the rest of the year, it is one of the best places to base yourself for a Rockies adventure, with some unique accommodations and quick access to some of the best hiking in the Canadian Rockies.

A quick walk down from the highway at this roadside stop leads to Mistaya Canyon, where the powerful Mistaya River plunges through steep, smoothed walls en route to joining the North Saskatchewan River.

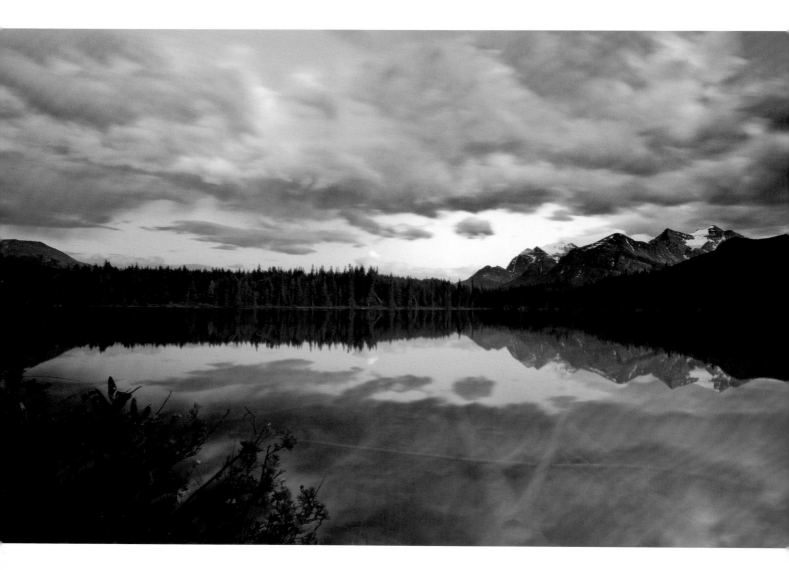

The last light of the day shines on Mt. Temple, reflected beautifully in the peaceful water of Herbert Lake, the first lake to greet visitors on the Icefields Parkway as they depart the Lake Louise area.

*The Crowfoot Glacier clings
to the northeastern flanks of
the peak that bears its name.
Explorers named the glacier
according to its shape, but due
to glacial retreat it has lost
a "toe" and no longer fully
resembles a crow's foot.*

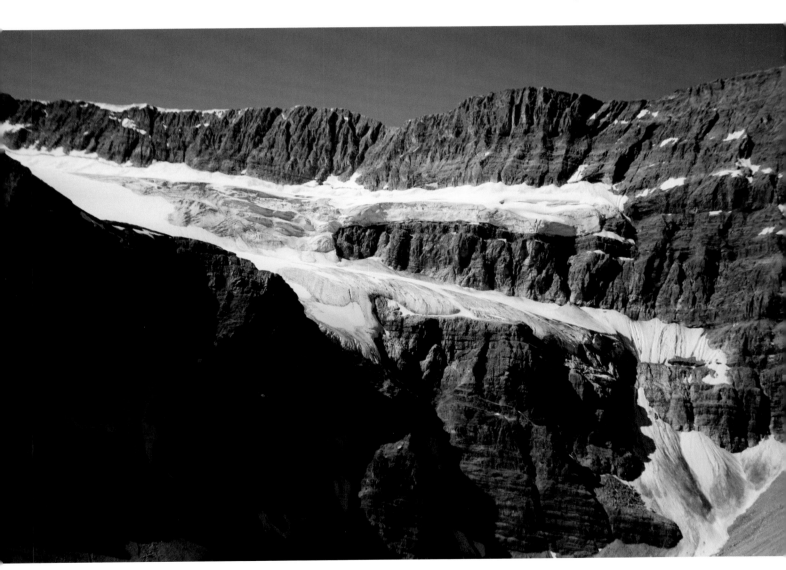

Crowfoot Mountain stands majestically over Bow Lake, the third-largest lake in Banff National Park. It is here that the Bow Glacier melts into Bow Lake – the headwaters of the mighty Bow River, which flows all the way to Calgary and beyond.

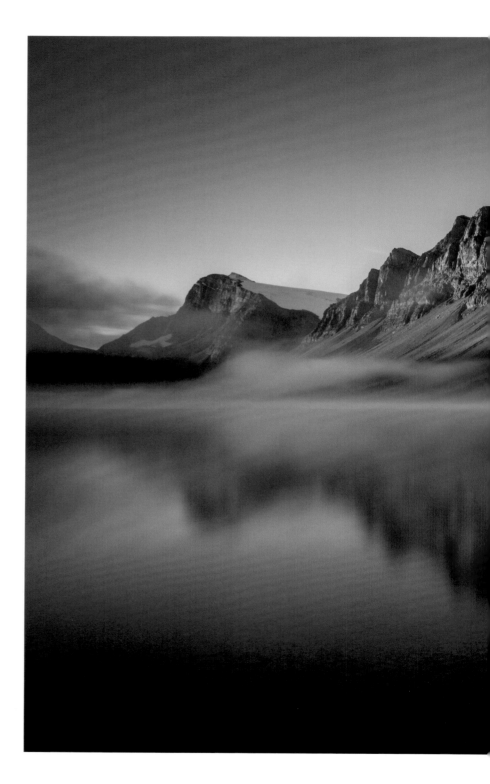

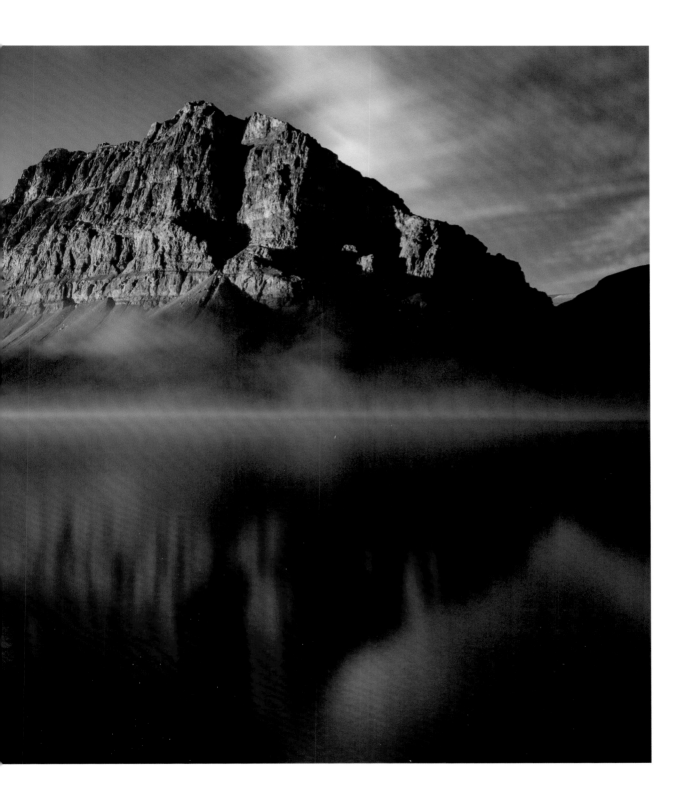

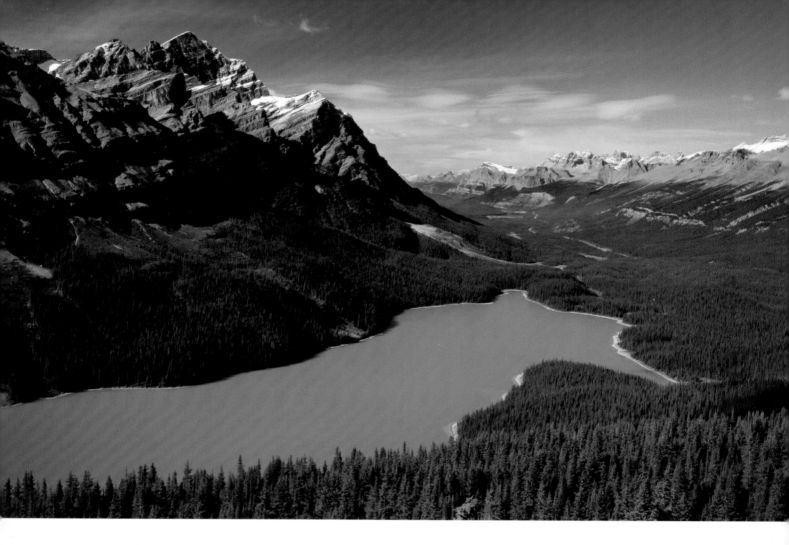

ABOVE *Famous for its opaque blue water, Peyto Lake is a popular stop along the Icefields Parkway. It was named after one of Banff's most iconic historical figures, the outfitter, guide and park warden Ebenezer William "Wild Bill" Peyto.*

OPPOSITE ABOVE *Two grizzly bears forage in an old horse corral close to Bow Lake. Sought after for sightings by locals and visitors alike, approximately 65 of these beautiful wild animals call Banff National Park home.*

OPPOSITE BELOW *At Parker Ridge, hikers can take a series of switchbacks to the crest for phenomenal views of the Saskatchewan Glacier. As the glacier recedes, it is forming a chalky blue lake – a new fixture on the landscape.*

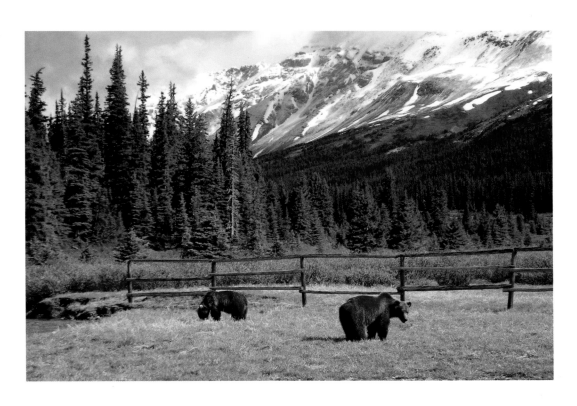

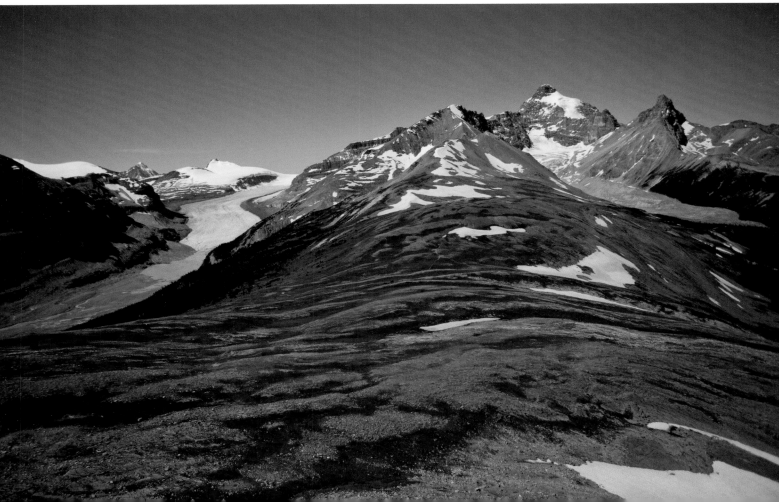

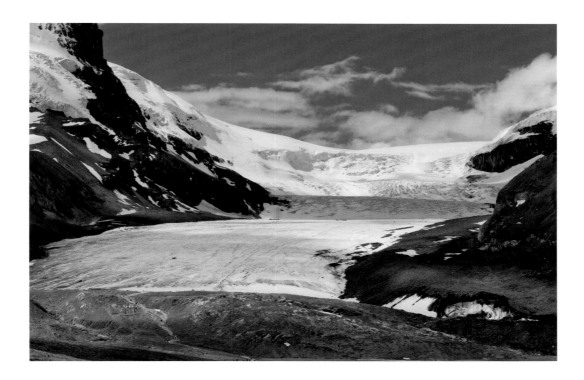

ABOVE *One of six "toes" that flow down from the 325-square-kilometre Columbia Icefield, the Athabasca Glacier is an impressive feature on the Icefields Parkway, reaching a depth of about 300 metres at its thickest point. This image shows people close to the toe of the glacier, and the Ice Explorer bus tours about halfway up, demonstrating the scale and magnitude of the ice. Remarkably, due to climate change, scientists estimate it has lost over half its volume in the past 125 years.*

OPPOSITE *Found throughout the Canadian Rockies, the prickly rose – known commonly as the wild rose – is the floral emblem of the Province of Alberta.*

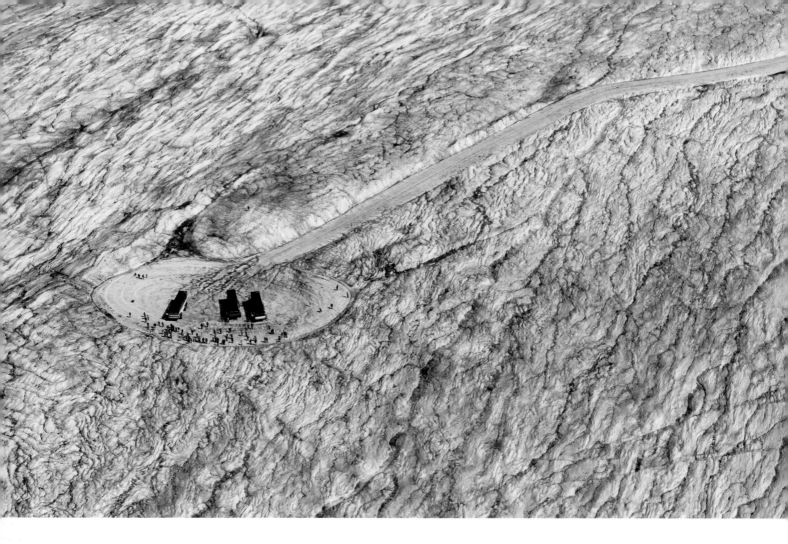

ABOVE *The Glacier Adventure is a two-pronged activity that first takes you right onto the Athabasca Glacier aboard an Ice Explorer bus (pictured here) before sending you for a stroll along the Glacier Skywalk, a glass-floored walkway that hangs above an impressive 280-metre drop.*

OPPOSITE *Athabasca Falls is known more for power than height: the water falls over tough quartzite and then carves its way through the softer limestone of the gorge below. Visitors can walk through fascinating eroded passageways of smoothed rock that the surging water has abandoned.*

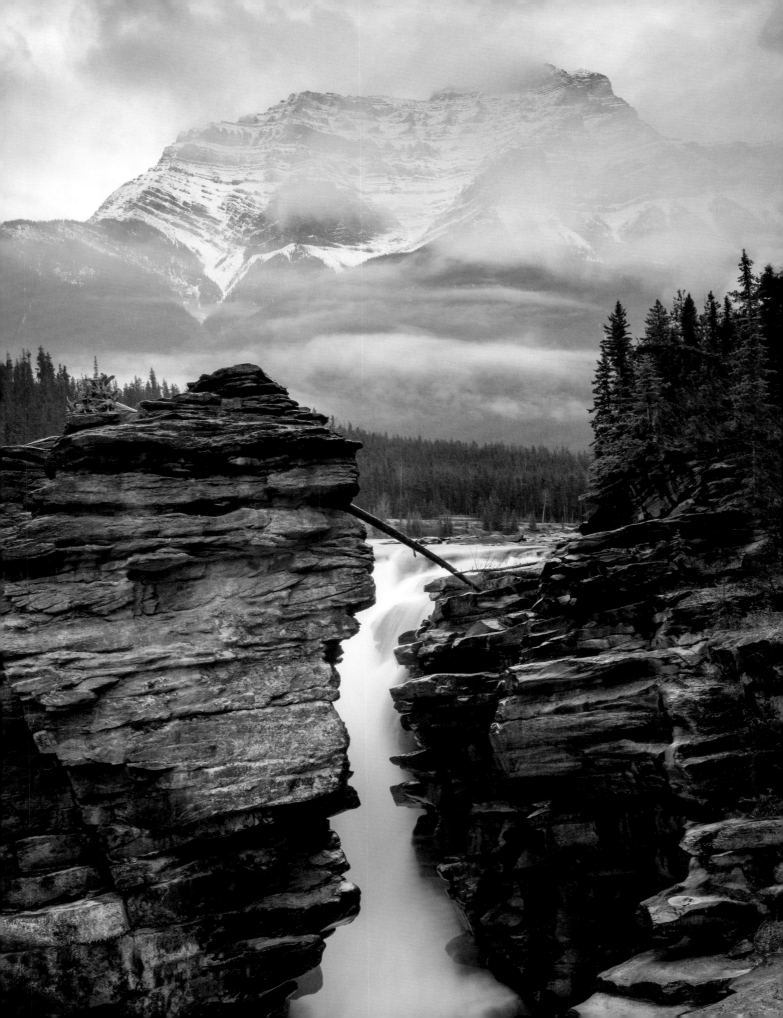

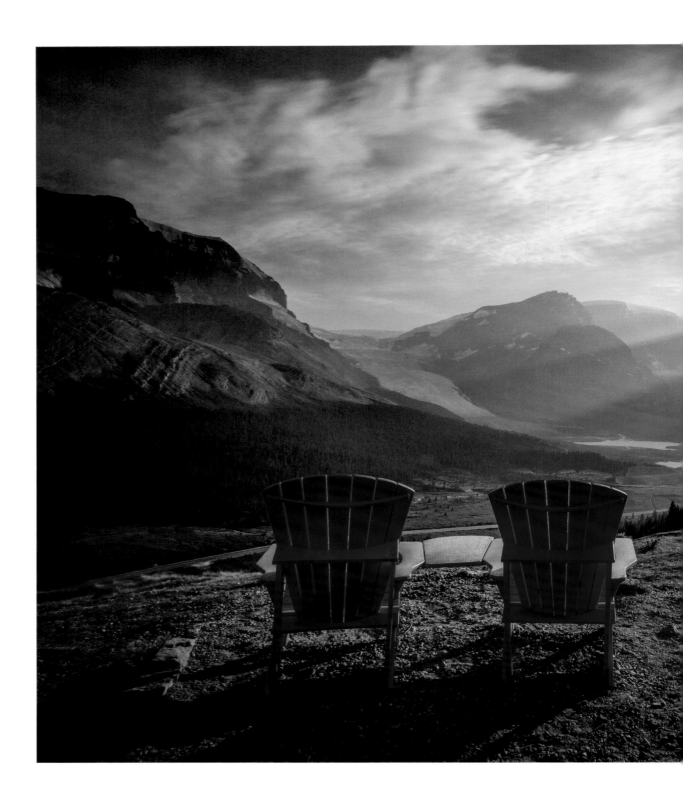

At Wilcox Pass, Parks
Canada's famous red chairs
give you a chance to pause
and appreciate the glorious
view of the Athabasca Glacier,
Jasper National Park.

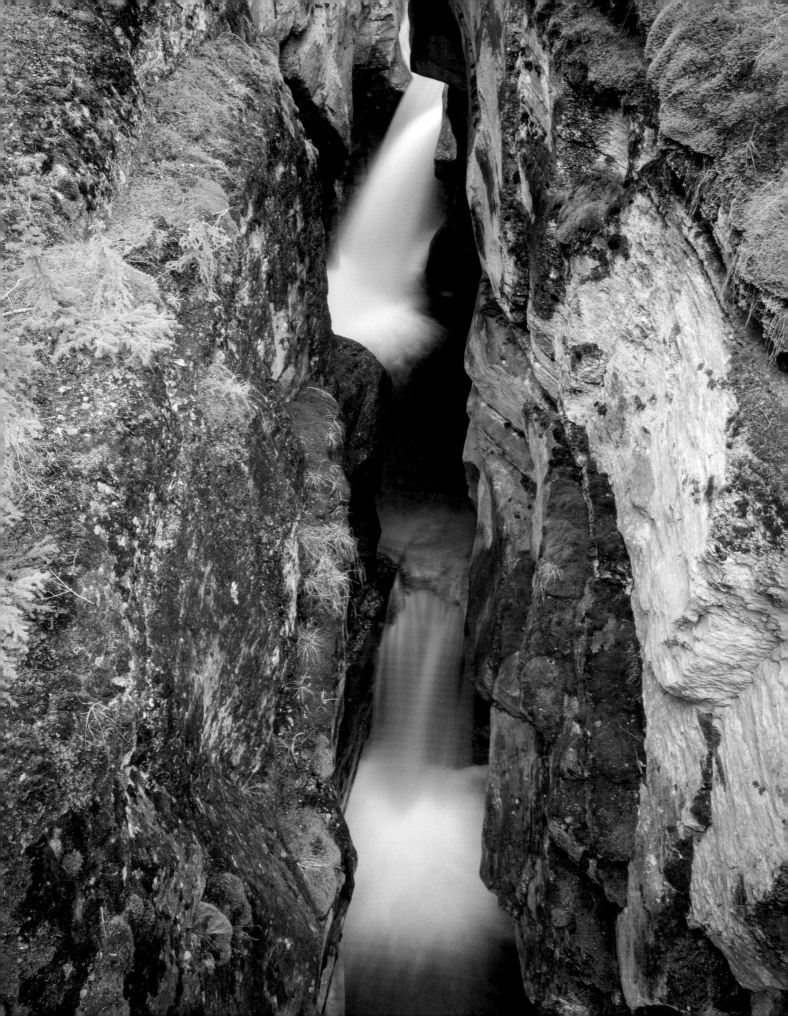

Jasper National Park

Established in 1907 and spanning 10,878 square kilometres, Jasper National Park is the largest of the mountain national parks. In addition to its vast wilderness areas, the landscape is marked by several accessible and scenic locations — powerful waterfalls that have carved the rock away, stunning lakes flanked by mountains, expansive valleys filled with trees and wildlife.

In the heart of it all is the town of Jasper, offering the same amenities and adventure as Banff, but in a more laid-back style. And don't miss the Jasper SkyTram on Whistlers Mountain, which takes you up to an elevation of 2277 metres for the best views in the area.

While you're in Jasper, remember to head out at night and look up. This park is proud to be the world's second-largest Dark Sky Preserve, providing some of the best stargazing you'll ever experience.

Measuring over 50 metres in depth, Maligne Canyon features a series of walkways and bridges suspended over the abyss.

LEFT The purple saxifrage gives a surprising splash of colour to a rocky landscape.

BELOW One of Jasper National Park's most iconic peaks, the illustrious Mt. Edith Cavell rises to an elevation of 3363 metres. Seen here from Pyramid Lake, the peak was named after an English nurse who helped Allied soldiers escape from German-occupied Belgium during the First World War. For doing so, Edith Cavell was arrested, accused of treason and executed by the Germans in 1915.

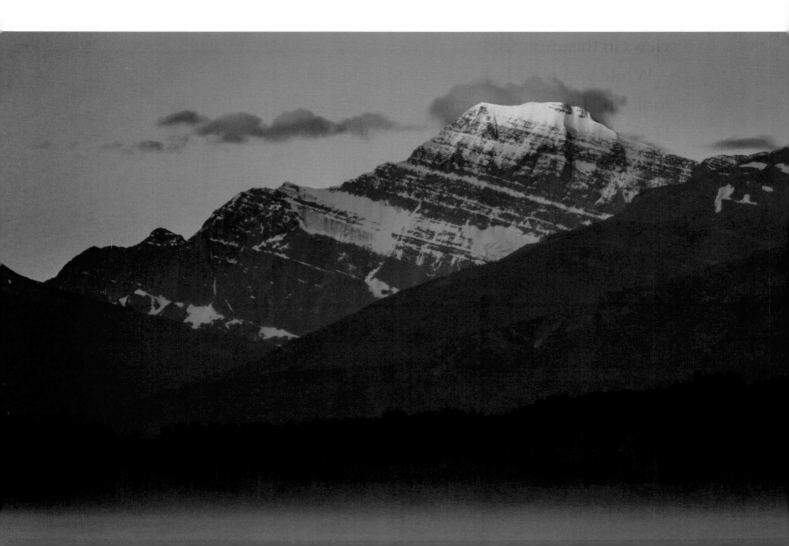

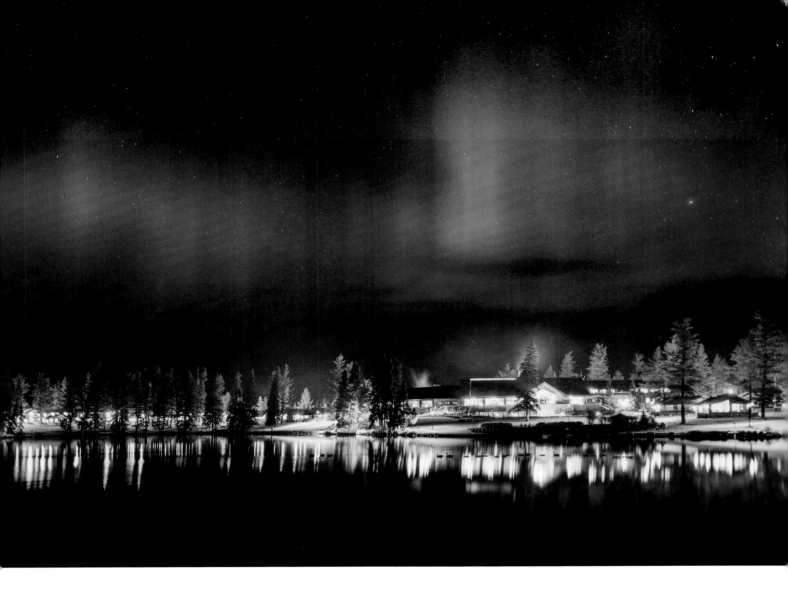

The northern lights dance
above Jasper Park Lodge,
which sits on the shores of
Lac Beauvert. First opened
in 1922, the hotel has hosted
many notable guests, including
members of the Royal Family.

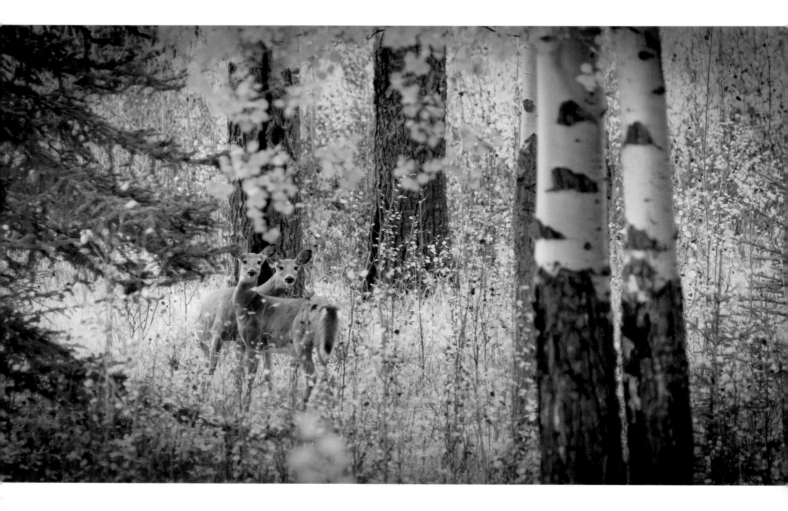

*Two mule deer peek through
the forest amidst the changing
colours of fall.*

One of the most famous views in the Canadian Rockies is that of Spirit Island and the dramatic scenery of Maligne Lake, originally called Chaba Imne ("beaver lake") by the Stoney. Mary Schäffer Warren was the first non-Native to reach the lake's shores in 1908, with the assistance of a map drawn by Samson Beaver. The name comes from the French word for "wicked," which was earlier applied to the fierce currents of the river that flows from the lake.

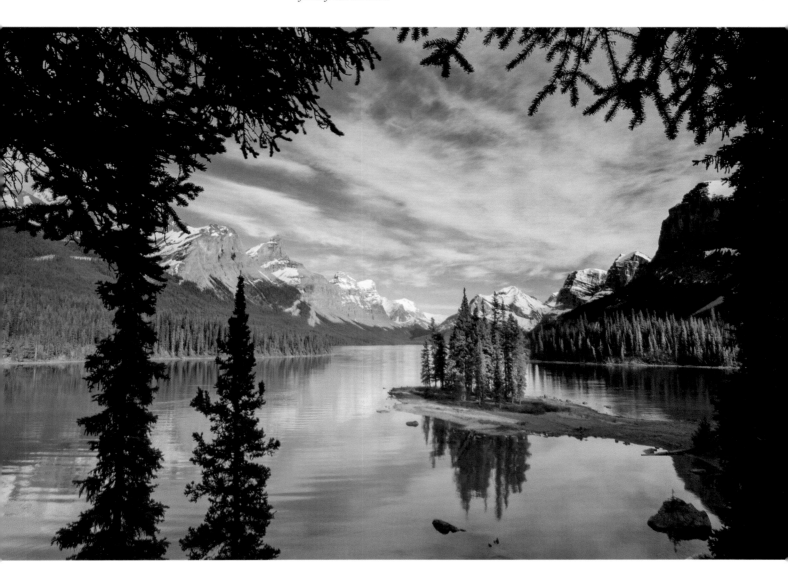

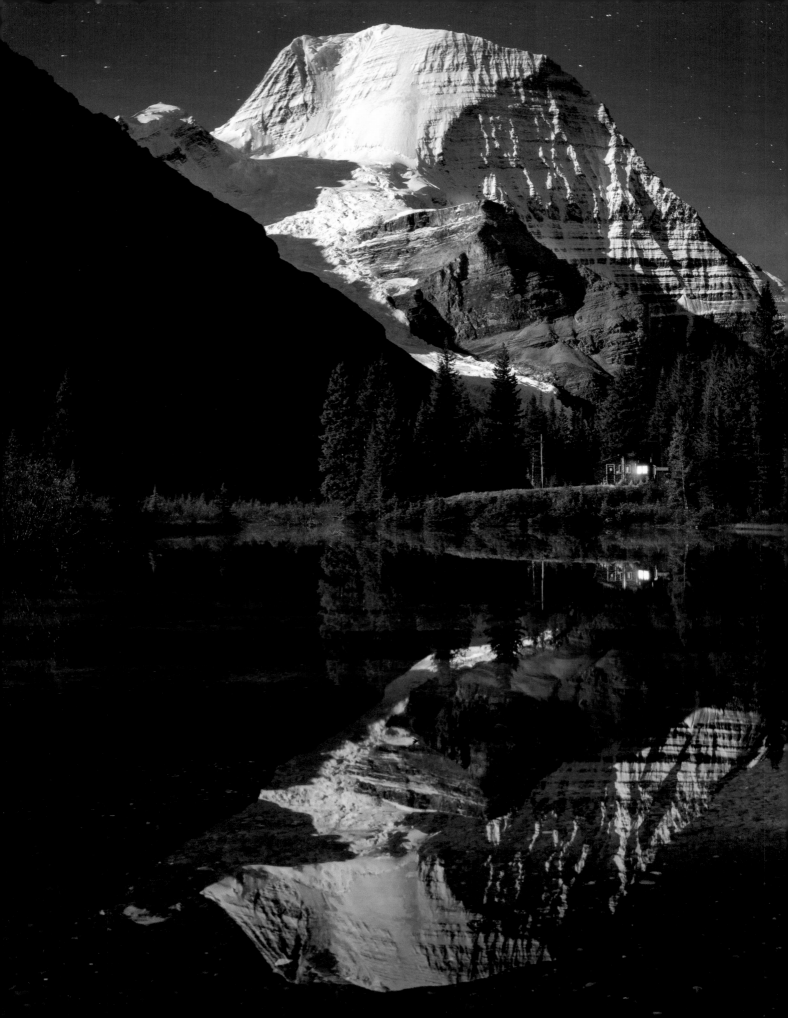

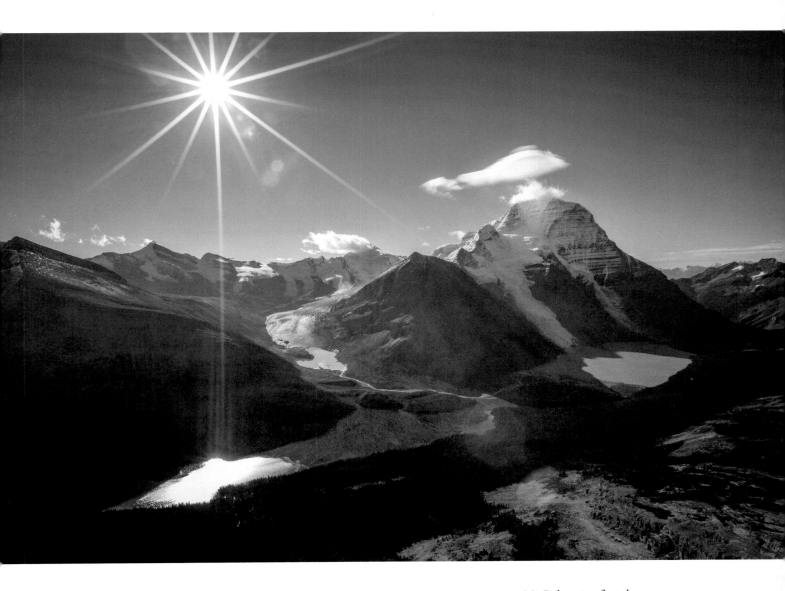

Mt. Robson is reflected in a pond under a star-filled sky near a ranger station in Mt. Robson Provincial Park.

Reaching a lofty height of 3954 metres, Mt. Robson is the highest peak in the Canadian Rockies and arguably the most beautiful. The peak is found entirely within the vast Mt. Robson Provincial Park (2249 square kilometres), which was established in 1913, making it the second-oldest in the entire provincial park system. Known to First Nations as Yuh-hai-has-kun ("the mountain of the spiral road"), the peak is often shrouded in cloud, earning it the nickname Cloud Cap Mountain.

Select Sources

The author wishes to acknowledge the following sources of information for this book:

Peakfinder.com

Wildflowers of the Canadian Rockies, by George W. Scotter and Hälle Flygare

Handbook of the Canadian Rockies, by Ben Gadd

Central Rockies Placenames, by Mike Potter

Banff and Lake Louise History Explorer, by Ernie Lakusta

The Canadian Rockies Trail Guide, by Brian Patton and Bart Robinson

Copyright © 2017 by Paul Zizka (photographs) and Meghan J. Ward (text)
First Edition, reprinted 2019

RMB | Rocky Mountain Books Ltd.
rmbooks.com
@rmbooks
facebook.com/rmbooks

Cataloguing data available from Library and Archives Canada
ISBN 978-1-77160-208-2 (softcover)

Printed and bound in Canada by Friesens

Distributed in Canada by Heritage Group Distribution and in the U.S. by Publishers Group West

For information on purchasing bulk quantities of this book, or to obtain media excerpts or invite the author to speak at an event, please visit rmbooks.com and select the "Contact Us" tab.

RMB | Rocky Mountain Books is dedicated to the environment and committed to reducing the destruction of old-growth forests. Our books are produced with respect for the future and consideration for the past.

We acknowledge the financial support of the Government of Canada through the Canada Book Fund and the Canada Council for the Arts, and of the province of British Columbia through the British Columbia Arts Council and the Book Publishing Tax Credit.

COVER *Moraine Lake and the Ten Peaks, Banff National Park.*

PAGE 2 *The bright green hues of the aurora borealis light up the shallow water of Medicine Lake, a unique feature on the Jasper landscape. In the summer it fills with glacial water to lake size, and in fall and winter it shrinks to mere pools in a mudflat, connected by a stream. Most interesting is the fact that no visible stream empties the lake – it drains out the bottom, through sinkholes.*

PAGE 4 *A gorgeous sight by day or night, Sunwapta Falls is an easily accessible stop in Jasper National Park. Sunwapta means "turbulent waters" in the Stoney language.*